Million Memories

Million Memories

Pallavi Kodan

PARTRIDGE

Print information available on the last page.

To order additional copies of this book, contact
Partridge India
000 800 10062 62
orders.india@partridgepublishing.com

www.partridgepublishing.com/india

Contents

To My Parents:

Mr Jagvinder Singh, Mr Uday Bhan Kodan
and Mrs Kiran Chaudhary, Mrs Kamal Kodan
who taught me everything in my life

Acknowledgment

This book is a story which is stringed by experiences of many people. An amalgamation of experiences and emotions.

In the journey of writing this book, I realised that I have been blessed with two of the most beautiful families, words are not enough to thank my families. I owe my greatest gratitude to my Parent in Laws, Ms Marina and Mr Aman all of whom have helped me big time. And needless to say my strength and pillar has been my husband, **Mr Ashish Chaudhary** who has been an equal partner in this endeavour. I am greatly indebted to my Parents, Parul, Amit jiju and Amol who have always been my strength and this book would not have been possible without them.

I have some beautiful bunch of friends and people who supported me throughout the book, motivated me to write the book. The book wouldn't have been complete without the help and support of them. A special thanks to Kriti Wadhwa for her invaluable suggestions and support. I would also like to thank Simran Kaur and Priyanka Tewatia

who are my constant support pillars. I would like to thank Saksham Sharma, who not only encouraged me to write but was also a big critic, helped with all images and graphics and edited the book and definitely deserves a special mention. Special thanks to all my friends.

A book is made by people who support and boost you up for working towards it, and people who have shaped who I am. Thanks to my alma matter, my school Bal Bharti Public School Pitampura and Delhi University for moulding me into what I am today. Thanks to all my teachers for being my guiding lights. Thank you to teachers Mr S C Baveja, My English teachers Ms Rashmi Ashtikar, Ms Geeta Lakhan Pal, Professor Gurdeep Sood, Dr Mohan Kapoor, Ms Anjali Shukla, Ms Neha Kapoor and all my other teachers for their role in shaping me and enhancing my capabilities to write this book.

I am thankful for the support of people like Mr Tanuj Garg, Film Producer who came forward with his help and I am extremely grateful to him. Also, Mr Sami Ahmed Khan, Author and my senior from school and everyone else who encouraged me. I would like to thank Dr Amit Hooda, Dr Kaushiki Kirty, Mr Neeraj Kumar, Dr Tripta Kumar, Mr Jagmohan Singh Kathuria and family, Dr Ram Kumar Sihag and Christine S Sihag for their advice and encouragement. I am thankful to the publishers of the book for making this journey smooth and beautiful.

Chapter 1

Waiting Can Make You Remember 'a Lot of Things'

Emperor's Lounge at Taj Hotel, Mansingh Road, Delhi, the best place to have milkshakes, muffins, and exotic coffee in the capital.

Yes, I am again here with my little champ, Udyan. He wanted to have his favourite yellow banana malt shake. So we ordered the shake for him with hot and exotic macchiato coffee for myself.

Watching little Udyan sipping his shake while having my coffee reminded me of my childhood days, where having milkshakes and drinks outside would be like a pleasure altogether. Life was much easier and simpler then.

I was brought back from my memories when Udyan suddenly asked me, 'It's my eighth birthday coming up! What will you gift me?'

What do you want? You tell me, I asked him.

'What did you got on your eighth birthday?' he asked me this question with an innocent smile and with a little excitement in his eyes.

These words immediately took me through the memory lane, to my memorable eighth birthday, which was made special and memorable by our best friend Karishma Seth, although we always used to call her Krisha only.

The reason why this birthday was so memorable because then eight–year-old Krisha prepared a halwa cake, obviously taking her mother's help, and painted a portrait of us three best friends with a caption written on it, 'BEST FRIENDS'.

She brought the cake and the portrait to our house. I remember my mother opened the door and when Krisha told my mom that she had brought a halwa cake for my birthday. My mother was so touched seeing this gesture from an eight-year-old girl that she asked me to only cut that cake for my birthday.

You will love to hear about her; she was our neighbour as well as best friend. It's not just my eighth birthday that we remember, we clearly remember her eighth birthday also. She asked us the same question in the same tone in which little Udyan asked me: what should I ask my parents to gift me for my eighth birthday?

We advised her to ask for new dress or a new schoolbag. Trust me, having a new schoolbag on your birthday used to make us feel at the top of this world. You show off and brag about your bag throughout your birthday month, or getting a new dress which you can wear on your birthday—the only day on which you can wear anything to the school, showing off everybody that it's your special day. But I guess these small things were special to us, as Krisha had always a different perception. We three were best of friends, but she has never listened to us about what we had suggested her (in fact, it's still the same as now.)

Let me introduce us here, or the other two people from Krisha's *best friend* portrait—Aashima, a.k.a. Ashi, and Siddhant, a.k.a. Sid. We three are best of friends, and being thirty-five years old now, I don't remember from when we knew each other.

Coming back to her, Krisha was totally confused as she was still not sure that what present she should ask her parents for her birthday. After rejecting the ideas that her best friends, YAAR, DOST gave, she started asking other kids from school and our locality for an 'awesome' gift idea for herself.

In this process, she discussed her confusion with a random guy from our class, Kunal, to which he replied, 'The coolest birthday gift would be "99 in 1 Video Game", if you have one, each and every kid from your school and your locality would want to be friends with you, and they'll praise you as well. Even I got the same on my birthday, and I am loving it!' And he showed off the game cartridge, with Mario's picture on it, which he has brought in school to exchange it from a friend of his.

The moment Kunal left, we saw a spark in Krisha's eyes like she has found something very valuable, and we understood that she has found what she wants on her birthday from her parents now: video game, which was the only thing there in her mind now. She was sure on buying a video game only because it was 'cool' to have it. Everybody advised her that she has never played it, so she should buy something that would be useful to her. But due to her stubborn and rigid nature, she didn't listen to anybody and convinced her parents to get a video game on her birthday; and the last time I saw that game attached to her television was her eighth birthday, and it made her

look cool for another three to four months, when she was bragging about her gift in a proud tone. Though her brother played with a lot and enjoyed also. It seemed it was a gift meant for him only.

'Arre, tell baba! What will you gift me?' Udyan brought me back from my memories.

'Do you want a video game?' I was laughing from inside, but then only you can understand why.

I was waiting for his reply to be in yes, but he surprised me. 'No, No I want a Spider-Man T-shirt and a colouring book and . . . comic books. Can I get these three things?'

His innocence just took me over. The way he was looking at me with those glittery eyes waiting for a positive reply. I smiled back at him and shook my head that I have agreed to his demand.

Chapter 2

Insight to the Big Family

While Udyan was sipping his drink and busy watching TV, I was staring at my coffee mug, with the hot steam coming out, and I don't know when I got lost into my memories of my childhood and the time spent with my friends.

Recalling the memories I had with my friends, how I shared my joys and griefs with them, how I involved them in each and every decision of life, from my career to my marriage—they were there supporting me. We didn't realise we were making memories that time; we just knew that we were having fun.

I was still in my thoughts when I heard the song 'Hum Saath Saath Hai', as somebody was scrolling the channel, and immediately it reminded me of Karishma and her *big* family.

She was born into a typical orthodox business family who wants the son to work and the daughter to get married. They had in their family *taya ji*, *tai ji*, and cousin Varun, Mom, Dad, and the youngest of them all, Karishma (the only girl in the family).

I have a clear memory of her mother and Tai ji wearing nice sarees every day according to their customs and traditions. Both of them, Krisha's mother and her Tai ji, were very religious ladies, organising kirtans, always busy in their religious trance. They even started this Kirtan Kitty, in which they used to had pujas and kirtans hosted by the kitty members at their houses on their turn. Karishma was also a firm believer of lord Krishna like her mother, but she was not that much into kirtans and bhajans.

Her father was a very strict and short-tempered man. I have always seen him with a serious face, and he also used to talk in a strict, authoritative tone—until few years when we gelled up together nicely and I came to know that he had a different side of him altogether, which we never knew.

Both Karishma's father and her taya ji were businessmen. Yes, the business clan blessed with a commercially bent mind, or we can say '*the business genius*'. They were almost born with business DNA. Kids of the family learn all the business tactics at a very young age; they have to learn all this as they are supposed to join their family business

The family's only son, Varun Seth, the guy who is the future of their garment business, was a pampered child. As he was the first son of the family, everybody used to infantilise him a lot. He was an intelligent boy, good at accounting and maths—true to the clan, a *pakka accountant* as well.

Varun was very serious about his studies, and he clearly knew what he wanted to do in life, and I guess he was moving towards his dream with the required pace. Varun was three years older than us, studied in the same school, Doon Public School, Paschim Vihar, where we three friends were. We three were average students, but on the contrary, Varun

was a sharp kid. He always used to top his class. He was the teacher's favourite student, calling him teacher's *anakh ka tara* would not be wrong (sounds too melodramatic, but that's how we can put him exactly in right words).

Karishma, being the youngest daughter of the family, was restricted and protected by everyone. She was never allowed to make her own decisions; everything was imposed on her—always.

Once she had to attend a family function, a distant cousin's marriage. Karishma wanted to wear a pink frock, which my mother gifted her on her birthday, but she was asked to wear a green suit instead of it. She told us, with moist eyes and trembling voice, how her father and taya ji were so much against their daughter wearing such a thing in a family function. We were in class ninth at that time, the age where we begin to start taking our decisions. But not in case of Karishma; she was only supposed to do whatever her family members ask her to do.

Karishma was once selected to perform a solo dance performance at school's annual function. She had been bent on dance since her childhood and was waiting for such an opportunity to show her talent from a very long period of time, and finally she got this opportunity.

Happy Karishma went home and told everybody that she has been selected to perform an act in front of the guests and the entire school on the Annual Day. She was expecting that everybody would get excited and will be proud that she has been shortlisted from so many girls of the school who were auditioned for the act.

Varun: NO, A big *no*! You'll not be doing any dance or any other stupid thing in front of the entire school.

Karishma: But why, Bhaiya? Teachers appreciated me and my talent that is why I am selected for a solo performance, not in a group act.

Varun: No means no. You want me to be a laughingstock of my friends? You'll not be performing, and that is final.

Taya Ji: Varun is right, Karishma, daughters of our house don't get into these things, and this is against our family customs.

Karishma: But, Taya Ji, I really want to do this, I won't get such a good opportunity in future.

Mr. Seth: Enough is enough now. You are not supposed to talk to your elders like this. If your Taya Ji is telling you something, you are supposed to listen to him instead of arguing. Varun is right. I don't want him to suffer because of your stupid dance thing.

Karishma: But, Papa—

Mr. Seth: I SAID NO! Am I audible or not?

(His pitch was high, and his eyes went red in anger.)

Karishma's mom and Tayi Ji took their husbands to their respective rooms, and Varun went out of the house, leaving behind Karishma standing mum with moist eyes in the living room, alone. Yes, she was broken, and it was the first time she wanted to do something with such a great passion and enthusiasm. That was also the last time, probably, where she knew what exactly she wanted to do.

We never saw her like that again 'wanting to do something'. After that, she just wanted to copy what was going on in the 'trend'.

Chapter 3

#Love Is in the Air

The school time love—you will agree with me on this that each one of us at least has had one fling in school days. If not fling, a crush who we thought was our true love and that we'd be together always. We misinterpret *infatuation* with *love*; we start wondering about a happy future with the person with whom we are in a relationship with or who our crush is. This happens with every kid in that age—they feel that this is love for them until they grew up and understand the deeper meaning of it.

It was the time of October; when we were having our Diwali break, after which our midterm exams were going to start of class twelfth. Sid has shifted to Dwarka after our class tenth exams, as his father got promoted with a house given to them as bonus. So it had been already more than a year that we three friends haven't been together, since the shifting.

We three really wanted to have fun and to spend time together, as it has been already a year we haven't seen each other, and what could be better than watching a movie in a multiplex.

In those days, there were only single-screen theatres. Those days we had gold- and silver-class seats available in multiplexes. There were *stall*—cheapest ticket, front seats; parents never wanted to sit with family in those rows. *Balcony*—family-class seats; not cheap and not that expensive. And then there was *box*—limited seats; bit costly. The canteen of single-screen theatres were used to serve chips, samosas, cold drinks, sandwiches, and chewing gums—only, they have a limited menu.

In 1997, Delhi got its first multiplex theatre in Saket: PVR Anupam. All three of us wanted to experience how a multiplex is different from the other theatres we have in the capital. So the venue was fixed; we planned to watch the movie *Dil To Pagal Hai*, which was released on 31 October 1997, Friday, the day after Diwali. So we decided that we'll go on Sunday for the movie. But there's always a difference between dream and reality.

We were just seventeen years old then, though we considered ourselves as grown-ups, mature individuals but still we were kids of class twelfth and are not allowed to go anywhere alone or with friends. Convincing our parents to let us go alone together was going to be a great task.

Convincing parents to something which they think is wrong or not possible is like a nightmare. We have decided that we'll do every possible thing to convince our parents and will make a successful outing.

'Wow, Sid is growing up now!' said Siddhant's massi to his mother after hearing that her nephew is planning to go out for a movie with two girls. While he was telling the plan to his parents, she was there. Luckily, his parents agreed and granted him permission to go alone with friends; were they that cool or was it because of his massi that he

got the permission, We really didn't know, and why should we care? At the end, he got the permission—that was more important. One position was secured now, two were left.

Aashima talked to her parents and asked them to let her go to the movie. 'Dimag thik hai tera? Are you out of you mind?' her mother replied after listening to her. Punjabi parents love referring their kids as *lunatic*, in a bold and high-pitched tone, every time they feel that they are saying totally illogical and senseless—and trust me, it happens almost always. (*Sigh!*)

'But, Mom!' Aashi said in a sad tone, but before she could speak any further, her father interrupted her and asked her whether she was sure about going alone to that far? Without any hesitation and any doubts in mind, she nodded and boldly said '*yes*'. That yes came out in a bolder tone than her mother's. Aashi's Punjabi blood was speaking now.

Aashi's father always had faith in her, since her childhood she hadn't demanded anything that was a waste for her. She was a sensible girl and always knew what was right and what is wrong for her. And after that bold yes, her father was convinced that she'll be okay if she went out with her friends.

'Okay, *go*!' Aashi's father said with a smile.

'REALLY?' Both Aashi and her mother gave same reaction after listening to her father's reply.

'Tussi bigadh rae ho! You are totally spoiling her by granting her such permissions.' Aashi's mother uttered those words in an irritated and angry tone. But her father asked her a simple, 'Is this your *worry* for your daughter or is this a *doubt* on your daughter?' in a very calm way by putting his hand on her shoulder. This question by Aashi's dad forced her mother to think that their daughter is grown-up

now and she knows what is right and what is wrong for her. She can take her decisions now, and they have to trust her wisdom, which she had shown since her childhood.

'THANK YOU PAPA!' Happy Aashima hugged her father with tears in her eyes. Those tears were not because of the happiness that she was going for the movie; instead they were there because she saw her father's moist eyes while he was telling her wife that he trusts his daughter. Nobody can write or tell what kind of bond of love a daughter and father shares; it can only be felt by a father and his daughter, I guess. As a Narrator I could feel each and everything that happened at her house when she told us about it.

Now we have crossed the two levels very easily, but to win, we need to cross the final and most difficult hurdle— convincing Karishma's parents. We knew that this would not be an easy task, so Krisha asked us to come along with her and help her convince her dad for the outing.

Mr. Seth used to sit outside the house, in the veranda, with his newspaper and tea in the morning, the best time to take his permission. We both the girls gathered courage, and we were there in front of him, nervous and scared.

'Namaste, Uncle! Good morning!' I greeted Karishma's father.

'Namaste, beta! Radhe Radhe!' he greeted me back with a smile on his face. 'How are you, Aashi beta? How is your preparation going on?' he asked me. Now this question about studies is complimentary for every kid form his/her parents; there are two motives out of which they always wants to prove: first motive in asking this is that they'll humiliate their own child after getting a positive and satisfied answer, the second would be humiliating both of them together. So next time your friend's parent asks you

that 'Padhai kaisi chall ri hai?' or 'How is your preparation going on?', just tell them they are going good and have completed a lot of subjects. In that way, your friend have to face the humiliation that too for some time, else they'll curse both of you when you are there and when you'll left they'll humiliate your friend more with words like 'Dost hi dhang ke bna lete,' 'Duffer GANG', etc etc..

'I am good, Uncle, and studies are going really very well.' I was sounding very confident and continued. 'This time we both are working very hard to score more than in our previous exams.'

'That's very nice beta, good to see your confidence. This is a crucial year, your entire life is dependent upon this year's result. Board exams are really very tough, don't take it lightly, and keep preparing harder and harder.' Mr. Seth told both of us this in a concerned tone while sipping his tea.

'We are doing the same as you are saying, Uncle, but don't you think that we should treat ourselves after working so hard?' I showed my quickness and smartness, but we were not ready for the reply that they were going to get.

'Yes! Yes! Beta, why not. I'll take you to Jwala Heri market where you can have the famous ram ladoos and softy cone on this Sunday, and whenever you'll feel demotivated, I'll always take you there,' Mr. Seth replied with a big smile on his face.

Both of the girls exchanged a stunned look. They considered themselves as two big grownups now, and they had definitely crossed their childhood, and soon they were going to be adults also and still, Krisha's father was asking them for a *softy cone* and *ram ladoos*? Really? They felt insulted. How can anybody still treat them like a kid?

Both of them realised that this will not work out like this, and they had to find another way to ask for the permission, but for that they wanted to prepare themselves properly. Otherwise both of them will have to play a 'rapid fire round' with Mr. Seth just like in *Koffee With Karan*, so they signalled each other, said goodbye to Mr. Seth, who was still sipping his tea, and ran away.

* * *

'Hello Ashi?' Karishma called on Ashima's landline.

'Yes, Krisha, tell me!' she picked up the call and replied.

'Hey! I've got the permission to go.' Karishma gave this news in an excited and happy tone.

Ashima was so surprised and amused. She was very keen and eager to know how she convinced her parents so easily. 'How? I mean, what did you tell your parents?' she asked curiously.

'Varun talked to them.' Karishma said.

'VARUN?' Aashima got more confused.

'Yes! Actually, when we were talking to Papa in the morning, he was watching us from the balcony. When I came back home after discussing everything with you, Varun asked me that what's the matter, what were we talking about with my dad in the morning,' Karishma told Aashima.

'Ahaaan! Then?' She still sounded confused.

'So, I told him that we had made this plan and we were trying to convince Dad, but we failed to even ask him about it. He said he'll talk to my dad and will convince him to allow us to go along him.'

'Him? Why him? Is Varun also joining us?' She got very puzzled.

'Listen quietly! Varun is going to meet her girlfriend on Sunday, and he wanted to take the car. So, if he'll be dropping us, no one in the house would object to him taking the car, and they'll be relaxed that an older person is there with us.'

'Ohhh! Like this!' Finally, she was able to fix all the pieces of the puzzle properly.

'Thank god! You got it finally. Chall, now I am hanging up! Will meet you tomorrow.'

After this, they both greeted each other good night and hanged up the call.

Finally, the day came for which we were waiting for so eagerly. All three of us didn't sleep the night before, and we were ready for the movie before time. Varun picked up each one us, and yes, we were there in the car, sitting together with smiling faces and *Dil To Pagal Hai* songs in the background; Sid recorded an audio tape for the outing. We were singing, dancing, shouting—and whatever we could do in the car, we were doing.

We reached our destination after an hour's drive. Varun asked us to not to go anywhere else; he'll be back by the time our movie is over and told us that he'll wait here where he was dropping us. Cell phones were not so common at that time, so these types of instructions were very common in those days.

We bought our tickets and entered the cinema hall. The moment we entered, the smell of popcorn and independence made us very happy—life couldn't be better. We purchased popcorns and cold drinks for each one of us and went inside to our seats, and the movie started in ten minutes.

It was intermission, and we were discussing how the movie was so far and what we liked in the movie the most.

Karishma told, "Kahi na kahi, koi na koi mere liye banaya gaya hai, aur kabhi na kabhi mai use zaroor milungi"—was her favourite dialogue from the movie.

'Hi!' a voice came from behind us. All three of us turned around to check who that was; Prateek Diwan, a guy from the school. Karishma had used his name in few conversations earlier, referring him as the cutest guy in the school. When she saw him in the theatre she thought that probably they have met for some reason. She was all into her dreamy world when Ashima and Siddhant, greeted him with 'Hi'. Karishma suddenly realised that she was lost in her thoughts and she tried to cover herself up by asking him questions, like 'How are you?', oYou liked this place?', oAre you enjoying the movie?' etc.

Prateek was there with couple of more guys to watch that movie, but he preferred leaving behind his group and sitting on the vacant seat next to Karishma. Both of them were talking and giggling from the moment the movie resumed after the interval till the end. Karishma could hardly figure out that her friends were getting annoyed by this guy as this was supposed to be 'their' day—and she was busy talking to the *cute* guy from school. She got so much involved in talking with this guy that she forgot that she was out with Sid and Ashima. We wanted to tell Karishma that it was our, us three's, first outing, so she should not spoil it, but we were already late as the movie was about to end. *Dil To Pagal Hai* title was sounding actually very true that time.

The movie was finally over and our first tnon-parental' and 'only-friends' outing was going to be over soon. We didn't expect such an ending to our outing. In our mind, a very apt song was coming for this situation: 'Dil ke armaan, aansuo me beh gaye'. What we had expected from

the day and what really happened were two poles apart thing.

We came out of the theatre staring at Karishma; she was still with that guy, talking and laughing. One of Prateek's friend called him from a distance, saying that it's time to go. So, he said bye and asked for Karishma's landline number, and she exchanged her number with him, also telling him the time when he should call.

We were still very angry and upset with her. She was not even looking at us as we waited for her. After doing fifteen byes and twenty handshakes, she finally came to us.

'It was a nice movie' the first thing that Karishma said to us after Prateek left.

'Did you even watch the movie?' Siddhant asked in an irritated and taunting tone.

'Guys! See, I was just talking to him. He is a cute guy. Come on! Grow up, guys! This is not a big deal' Karishma tried to explain herself in a defensive manner.

'Oh yeah, not a big deal, right!' Siddhant was sounding irritated.

We didn't wanted things to get ugly between us three on the day that was supposed to be the most special day for us. She reminded us that Varun will be waiting for them outside.

We were in the car and Varun seemed to be very happy. He wanted take us to some restaurant for us to have food. But none of them seemed to be hungry or rather we can say all of them wanted to go back home and not to increase the fight.

Varun still took everybody to the newly opened McDonalds in Vasant Vihar, the first outlet of Delhi, where they had finger fries and Coke just for Varun's sake.

We were back in the car; Varun was driving us back home. He tried to start conversation one or two times, but to his surprise he was not getting any proper reply. Soon after these failed attempts of conversation. Silence was there in the car, dead silence that we could hear each other's saliva gulping sounds.

The much-awaited outing was over, and we were back in our homes. All three of us wanted to call each other, but none of us took the initiative.

After two days, finally, Ashima called Karishma. Karishma sounded very excited. She told her all that happened in those two days. She told her that she and that guy talked on phone.

'Aashi, you know, I am so happy, that guy is so so cute. I just love talking to him. We talked for an hour yesterday,' excited Karishma told her.

Ashima was little taken back from what she heard but she tried to sound normal. 'Oh! Wow, that's great! What did you talk to him about for an hour?'

'You come and meet me, I'll tell you everything. One more thing I wanted to tell you that we both are planning to meet tomorrow. He asked me for a coffee in Vikas Puri, Barista, and I couldn't say no to him.'

Ashima, though speechless for some time, said, 'Really! How will you go? Is it your first date, Krisha? I am so confused right now. Are you sure he is the right guy?'

Karishma said, 'Just relax, Aashi. He is a very nice guy, don't worry. I can't wait for tomorrow.' She further added, 'I will say that after our extra class, we both are going to get notes form one of our friend in D-Block.'

'Are you sure you want to do this?' Aashima asked in a worried tone.

Karishma answered her, 'Yes, sweetheart! Don't become my mother now, and listen, don't tell this to Sid. He is like a girl, he will get upset again.'

'Okay, don't worry, be safe, and call me when you'll come back tomorrow,' Ashima replied in a concerned tone.

'Ya! Ya! Sure! Chill now, goodnight.' And Karishma disconnected up the call.

Though Ashima was not comfortable, But she knew saying anything was useless.

The next day finally came, Karishma got ready for her special big day: H*er* F*irst* D*ate.*

***** **First Date** *****

Mr. Prateek came to pick Karishma from the coaching centre, at B Block, in a grey-coloured Hyundai Accent, with tinted windows. He was wearing white shirt and blue jeans and a black-coloured aviators.

Karishma was looking very beautiful wearing a bright red and yellow T-shirt and black jeans. She was carrying her favourite perfume, which had fragrance of roses, in her bag, which she applied after her class.

'My! My! Someone is looking very pretty, and this fragrance is really very good,' Prateek complimented Karishma the moment she entered the car.

Karishma was blushing; she wanted to compliment Prateek as well but she got so overwhelmed with his compliment that she couldn't speak.

Prateek ordered cold coffee for both of them and chocolate muffin for Karishma.

'So, what are your hobbies?' Karishma asked him.

'I love playing basketball and driving, and now I love talking to you on phone,' he replied with a witty smile on his face.

He was trying to flirt with her, and Karishma was actually doing the same. This was happening with her for the first time. She was into her love trance.

After they finished their coffee, they started heading towards the car. Karishma was feeling bit sad as she didn't wanted to go home that early as she was loving his company.

They both got into the car and Prateek started praising her. *'You are very beautiful, I can't get my eyes off you. The day from which we have started talking, all the time I keeps on thinking of you. You have made me a pagal completely.'*

The dude tried to charm Karishma with flirting in his English (the only problem was, he knew very less of it), but she didn't find it weird, it was *cute* for her.

While charming her with his words, Prateek started caressing her hands and shifted closer to her. Karishma was blushing at that time, and her hands were freezing cold; she was nervous.

'You are very cute Prateek. I loved the way you talk to me and look at me. I feel like talking to you 24/7, 365.' Karishma's voice was bit husky.

Listening to this, Prateek leaned forward and dropped a kiss on her cheeks. It was the first time a guy has placed his lips on her cheeks. She felt very good and a bit aroused, and in return, she kissed him back and said, 'I love you, Prateek.'

'I love you too, my Krishi,' Prateek replied back and kissed her again on her cheeks. She felt his lips moving slowly, slowly from her cheeks to her neck. The warm breath from his mouth was arousing her a lot; her eyes were closed,

and there was an electrifying sensation in her entire body—she was aroused now.

She suddenly whispered, 'I love you!' to him and looked into his eyes.

Prateek replied and moved forward again, and this time he placed his lips over her lips. Yes, it was Karishma's first kiss, on her first date. She was not in a state to think that whatever going on was right or wrong—both of them were kissing each other very passionately.

She just didn't want it to get over. While kissing her, Prateek slid his hand inside her top. This action took Karishma's excitement to the next level. She was moving her hand on his back and hugged him tightly.

They were sweating, breaths were heavy, and yet their lips were locked.

Prateek tried to go little more upward in the top but this act brought Karishma back to her senses as she was not ready for it.

'NO! Don't be that naughty! This is our first date.' Karishma broke the kiss, which was going on for the last seven minutes, with these words, holding Prateek's hand outside her top.

'But why? You told me that you love me.' Prateek questioned her.

'Baby! Not now. It's just our first date, and I am getting late also. Please drop me at Peera Garhi,' she asked him in a pampering tone, with her hand still on his head, playing with his hair, and this time she leans forward and drops a small kiss on his lips.

After an hour or so, Prateek dropped her at Peera Garhi Chowk. This was the best day of her life. She was smiling, she was blushing like never before.

'What are you thinking? Your hot coffee is now cold!' a voice came from behind—it was Udyan who had finished his yellow banana malt shake. I realised it was already half an hour since I got lost in my memories. I started sipping and finishing my macchiato quickly.

While I was finishing my coffee, Udyan asked me, 'Do you used to have tests in your school?'. Kids! You cannot sense what's going in their head and what question they'll fire at you the next moment.

'Yeah! We used to have lots of tests. Why, what happened? Why are you asking this?' I enquired him.

'No, I was just wondering if I am in a right school or not because I have to give so many tests. You have seen how much I've to study' he sounded irritated.

'Ha ha ha! My dear, its part and parcel of our life. You are very young to understand it. you'll come to know what role these tests play in your life when you'll grow up,' I replied while pulling his GOL GAPPA cheeks.

* * * * * **Exam Trouble** * * * * *

That small conversation with Udyan, took me back to my exam days—'*boards*'. The name used to create fear in everybody's mind. Pressure of completing syllabus months before the boards, joining crash courses at coaching centres, round-the-clock exams at both school and coaching centres, and that pressure of scoring used to be there in our heads all the time. Scoring above 70 per cent meant that you'll be getting admission into the college that you have dreamt of, each and every person from your family and relatives will praise you, and a feeling of safe future—not like nowadays,

where even the cut off's of the colleges go up to 100 per cent in the first list. Crazy, right?

Our exams were round the corner, only two days were left for our twelfth board exams. We were tense, we were worried, and we were nervous as our future was dependent on the result of these exams.

'I am very nervous, I am very nervous, yaar!' Paranoid Karishma entered into Ashima's house, chanting these words. 'We are fucked! I am too scared!' she added.

'What's the matter? Can't you stay calm and normal and then tell me what is bothering you?' Ashima asked her, placing her hands on Karishma's shoulders.

'I am too nervous yaar! Shruti (random school girl) just called half an hour, back and she was saying that paper would be very difficult, and now I am not able to study,' Karishma said in a worried tone.

'Relax, Karishma, how does Shruti know that the exams would be difficult? Why do you even listen to other people? She was just trying to make her feel nervous,' Aashima tried to calm Krisha down.

Irritated and frustrated, Karishma replied, 'I don't know yaar! Can you please call Sid?' she requested Aashima.

'Haven't you talked to Prateek? What did he tell you?' Aashima enquired her.

'I don't know where the heck that guy is. I tried calling him twice or thrice, but every time his mother picked up the call and said, "Beta, he is not at home, he'll be back in an hour or so, any messages?" So irritating. Please, Aashi! Don't talk to me about that swine, I really feel like talking to Sid right now.' And she started dialling Siddhant's landline and put the phone on speaker.

'Hello?' Sid sounded relaxed.

'Hey, Sid! Shruti just told me that paper would be difficult, and I cannot study now,' Karishma said without taking any breath.

'Why do you care, Karishma, please study, that's what gonna make your difficult paper into an easy one. Talking on phone or not studying will not help you,' Siddhant replied in an irritated tone.

'Yes! Sid is right. Don't listen to anyone, Krisha. Shruti was trying to play with your mind. You know *how* she is, and I don't know, why do you even talk to her?' Aashima sounded irritated too.

Karishma gave an 'Hmm!' reply to both of them.

'Just *hmmm*? Are you getting us, what are we trying to say? Just stay calm and study—that is the only *mantra*,' Siddhant further told her.

'Yeah, yeah! I understood now. Okay then, bye, Sid. I am going to my house to study now. Will call you after the exam now,' Karishma said in an annoyed tone.

They all wished 'All the best' to each other and hanged up the call. Karishma went to her house and all three of them studied the whole night and night after for all the exams.

Board exams went fine, and all three of them scored decent marks also. But Karishma still could have scored better, but she couldn't because she was too nervous to study. All she did was to call people, and ask them how much they've prepared? What to study and what not to study? Will exam be tough or not? Should she do this topic or leave that topic?

Karishma was so confused between right and wrong. She was just bragging that she had to study, but she did not prepare at all—anyways, that's how she was.

* * *

'Let's go to the swimming pool. I want to swim.' Udyan brought me back.

I just looked at the time; it was 1:00 p.m., and going to pool was not a bad idea at all, so we headed towards the swimming pool to get relaxed.

Chapter 4

First Breakup

'I guess I am done with you Prateek,' Karishma said with an attitude.

Prateek and Karishma were meeting two weeks after their board exams ended. She was angry on him, as he didn't attend to her calls during the exams, and he didn't even inform her that he was going for a four-day trip with his coaching friends.

'How can you say that you are done with me? What have I done? Why are you throwing this attitude on me?' Prateek asked her in a very surprising tone.

'Oh! So you have this audacity to ask me this question? You were not there when I needed you the most. You went to the trip without even telling me. It doesn't matter where you go, but at least you could have informed me, *right*?' Karishma's temper was very high.

'What do you want from me then?' Prateek asked.

'I don't want to be with you anymore. I am done. I want somebody who'll be there for me when I need him the most rather than a guy who thinks I am just his *status symbol*, that

I am his girlfriend, in front of his friends and acquaintances.' Karishma's tone was very rude this time.

'Mind your tone, Karishma. I am not like your stupid friend, Sidharth . . Siddhant—whatever his name is and who'll listen to each and every crap coming out from your mouth without reacting. You don't want to continue this relationship, okay fine! Let's end this up now. I also wanted to say that I can't *take* you anymore.' Prateek started his bike and left the place, leaving Karishma behind, who was still standing there in an anger. She wanted to answer him back, but that coward ran away and never showed his face ever in Karishma's life.

That was the breakup, but the most surprising part of it was that none of them actually tried to get in touch with each other or say sorry or even try to resolve things. They had a *mutual* break up, or we can say they were just trying to get an excuse to get over each other, which they finally got.

IF THE FEELINGS ARE MUTUAL,
THE EFFORTS WILL BE EQUAL

We were done with our board exams and finally, we were in college now.

Karishma wanted to go in finance line, so she joined BBA course in one of the institutes in IP University.

Ashima wanted to go into mass communication field, so she joined Mass Communication and Journalism in Delhi University.

Siddhant got admission in B.com Honours, in Hansraj College, where he got selected as a vocalist in the Dramatic Society as well.

* * * * * **The Confession** * * * * *

'Love' is a feeling that is very special. For me love is friendship, trust, care, and responsibility. The feeling when you realise you want to spend the rest of your life with somebody.

When Siddhant came to know that Karishma broke up with 'Mr.Prateek', he was happy. He was relaxed in some way due to feelings he had since a very long time. He never confessed his feeling before to anyone. But now he wanted to.

'Aashi, I want to tell you something. This is kind of personal thing. Please understand it.' Siddhant called Ashima and sounded excited and happy.

'Is it about Karishma?' She asked Siddhant directly. 'Sid, I know you from childhood, and I always knew that you like Karishma. I was waiting when you will tell me.'

Siddhant still couldn't believe that she knew it all, which he was afraid to confess.

'I am so happy that my two best friends would be together. Wait! Have you told her?' she asked him curiously.

'No No, I haven't told her, and not even planning too,' Siddhant immediately replied.

'Why? Do you have something else in mind?' she sounded puzzled.

'I will tell her when the time will come. Right now, she will not understand my feelings for her as *love* for me is not how *love* for her is,' Siddhant said. He had a sadness in his voice.

Still Siddhant felt relaxed that now he can share his feelings for Karishma and there is somebody who will understand him.

What else do you want in life? Siddhant now had a friend with whom he can share whatever he wants to and his other friend was *the love of his life*!

Chapter 5

The First Adult

Aashima was the first among the three who was turning eighteen. Eighteenth birthday is very special for everyone—the feeling of turning into an adult wows everybody. No restrictions, no permissions—you have a license to do anything, nobody will impose things on you, and you have a right to think what is right and what is wrong for you (at least that's what you think and expect from 18th birthday).

* * * * * **Gift** * * * * *

'Hey, Krisha, have you planned any gift for Aashi?' Siddhant called Karishma and asked her.

'No! I haven't planned anything right now, but I have few things in mind. Why don't you come and meet me in Kamala Nagar market? We can get something together,' Karishma asked Siddhant.

'Haan thik hai! I'll meet you near Bungalow Road by 2:00 p.m. then?' Siddhant replied.

'Yeah I'll meet you near Amitabh Guest house by 2:00 then,' Karishma agreed and hanged up the call.

So both of them decided to meet and buy gift for Aashima from Kamala Nagar Market. Siddhant was coming there directly from his college, and Karishma had bunked her college.

Siddhant was very happy and was waiting for Karishma, standing in front of Amitabh Guest house on Bungalow Road. As he came directly from his college, he was not that dressed up; he was wearing sober clothes with a guitar and his college bag. He saw a flower vendor and thought of buying a *rose* for Karishma. He bought one and safely kept it in his bag, over the books.

Karishma came there in auto. She had changed her looks. She was wearing a long skirt with orange-coloured top; she had a new haircut. She was wearing eyeliner, a light pink-coloured lipstick, and was wearing the same perfume. Siddhant loved that fragrance. She gave a smile to Siddhant, and for a second, he couldn't even speak or smile back at her. He was amazed and stunned after looking at her.

'Ahm! Wow! Hi! Let's sit somewhere and decide what we shall give Aashima on her birthday, and from where,' Siddhant asked her.

Karishma didn't show any kind of excitement even when they were meeting after such a long time. Karishma said, 'Let's go to Bindals. I am sure we will get something cool there. Let's not waste time. I have to meet a friend. So let's quickly finish this up.'

Sid felt bad because they were meeting after a very long time and she had no time for him then also. He thought why did she even call him then.

'What do you want to buy exactly, Krisha? I was planning to buy a gift that is useful for her, something which she can cherish throughout her life or if not then something which would be useful to her,' Siddhant told her.

'No, Sid, don't sound so boring. Let's gift her some T-shirt with some stupid quotation. This is in fashion, and there are so many of them at Bindals.' Karishma sounded as if she had set her mind in buying only that, no matter what Siddhant said. From her eyes and facial expression, Sid understood she knew what to buy, and whatever he said would be useless.

'I don't think Aashi will like it. Why buy a T-shirt with stupid quote? Where will she wear it?' Siddhant asked her in an irritated tone, still trying his best to change her opinion. But it was like throwing an arrow in dark and being sure that it will not hit the target.

'You don't have to talk to me like this, Sid. Don't be so un-cool. I like those quoted T-shirts, and I am sure it will suit Aashi.' Karishma said in a raised voice, without understanding what Siddhant was trying to say.

They both had an argument, and Siddhant finally decided to give up.

'See, Siddhant I have to leave early as my friend is about to reach Kamla Nagar. Let's quickly buy it.' Karishma was hurrying up towards the store.

They went and bought a cup on which it was written, 'You can never get a right guy because you are a loser'.

Sid was very irritated over why she was buying that stupid, sarcastic T-shirt. It wasn't 'cool' for him, but Karishma was in her own trance. She was thinking that whatever she'll like, she'll pick for her best friend, and her best friend will like that too.

She then picked up a key chain on which it was written, 'Live and let live'.

'It's done, I am sure she will love them. Sid, what do you say?' Karishma sounded happy and excited.

'Ya! I hope.' Sid replied sarcastically. Moreover he was just trying to say what she wanted to hear; otherwise, they might end up in an argument again.

'Okay! Now I have to leave, Sid, catch you later, bye,' Karishma said these words in one breath.

Siddhant told Karishma that he will be staying in Paschim Vihar for a week as they were getting whitewash done in the house. So if she was free, then they can catch up. Karishma said okay and bid him goodbye. Siddhant saw a guy waiting for her across the road on his Bajaj Pulsar. Karishma waved him and sat behind him with a hug.

Karishma left, and Siddhant was in a very bad mood. He went to another gift shop and purchased a photo frame—a big one. He planned to make a collage for her, which she can put in her room as a remembrance. He opened his bag to take out his wallet; he saw that rose which he had bought for Karishma. Siddhant was trying to forget what had happened, but that rose acted as salt on the wounds. He came out of the shop with the frame in one hand and flower in other hand. He threw it on the road, looked at it, and left.

* * * * * **Birthday Party** * * * * *

Finally, the clock struck twelve and the doorbell rang. Aashima's mother opened the door. Siddhant, Karishma, and Varun were there standing on door with a cake and her gifts along. They all greeted her mother with 'Namaste'.

'Namaste! Siddhant! How are you, beta? And, how are your parents?' Aashima's mom asked Siddhant in a surprising tone as she was not expecting him. 'Let me call Aashima,' and she shouted Aashima's name in such a high-pitched tone that it could have reached up to three houses next to theirs.

Aashima was so happy to see Siddhant especially as they were meeting after a long time. She asked him about his college and whether he got selected in college's band.

Karishma also listened to all these things and was surprised to know that Siddhant was the lead singer of his band in college. She complained to him why he didn't tell her, but Siddhant dodged her with some excuse as he didn't wanted to spoil Aashima's happy moment.

They cut Aashima's cake and posed for a few pictures with Varun's camera. Yes, it was a beautiful surprise for Aashima. She had happy tears in her eyes seeing both her friends were there with her. That was the best gift.

Then Karishma excitedly asked her to open her gifts, and Aashima was excited too to open them. She opened the T-shirt first, and after reading the quote, she was surprised. She stared at Siddhant, who signaled it was Krisha's choice. Aashi could also make out.

'Isn't it wonderful, Aashi? It was my choice. Did you like it?'

Krisha wanted to hear her say so, and Aashi knew it. So, she knew what to say. 'Of course, sweetheart, it's so nice of you to put so much efforts for me,' Aashi told Karishma in a fake, pampering tone.

Then Siddhant came up with his gift. The frame was wrapped in the gift paper, and Karishma was saying, 'It's a painting, it's a painting,' again and again.

Siddhant handed the gift to Aashima, and she started opening it with a smile.

'O MY GOD! WOW!' Aashima was amused, and her eyes were glittering after seeing the collage and added, 'Thank you so much, Sid. This is so thoughtful and very beautiful,' staring again and again at the collage, which had the pictures that Siddhant had, pictures since childhood taken on various occasions, from birthdays to any function in the locality.

'THANK YOU SO MUCH, GUYS!' Aashima was touched, and there were little tears in her eyes as well.

Karishma got upset as to why Siddhant didn't tell her about the collage and why he gave it as 'his gift' and not as 'their' gift.

Siddhant tried to ignore her for some time because he didn't wanted to spoil everybody's mood. (He was already upset with Karishma.)

Aashi said goodbye to all, and Varun, Siddhant, and Karishma left, saying, 'Let's meet tomorrow in the morning.'

* * * * * **Cannaught Place** * * * * *

They planned to visit Nirulas in CP. Nirula's is India's oldest restaurant chain. It was Delhi's first fast-food restaurant, opened in CP in 1977.

Karishma and Siddhant reached early as they left together, and Aashima had to visit Hanuman Mandir with her parents and was joining them after that.

Karishma was wearing a black shirt with blue jeans. Her shirt was tucked inside the jeans with a nice belt on it. She still had the same perfume. Siddhant has grown his hair; he

was wearing a green jacket and white T-shirt underneath, with black jeans and a bandana—rock-star look.

'Let's go outside while Aashi is still not around,' Karishma asked Sid.

'Why? It's very hot outside,' Siddhant asked in a surprised tone.

'Arrey! Come for five minutes only,' Karishma said and went outside. Siddhant had no other option and followed her.

'Bhaiya! Ek Classic Dena!' Karishma was standing at a cigarette shop and had asked for a stick and started smoking.

Now that was something that Siddhant never expected. He was shocked! He felt as if that was just a dream. He had never thought that Karishma would ever do anything like this. But this was the reality—hard to digest yet very true.

'When did you start smoking, Karishma, and why?' asked Siddhant, still very surprised.

'It's the coolest thing, dude. Everybody does it, big deal!' replied Karishma nonchalantly while throwing the smoke on Siddhant's face.

'I don't know anybody who do it, but anyways, your wish,' annoyed Siddhant replied.

'So, how's your band going Sid? Have you composed any song?' asked Karishma, still having that half cigarette between her fingers.

'Yes! A few of them already done, working on two more,' replied Siddhant, still in annoyed tone.

Meanwhile, Aashima could be seen coming towards them. Karishma immediately threw away her cigarette and asked Siddhant to be mum in front of Aashima and went inside when Aashima reached.

They ordered milkshakes and burgers; they talked a lot. The three of them—after all their differences, fights,

irritation—were still together talking, giggling, cracking jokes, and making fun of each other.

Yes, that's how friends could be miles apart but still close to the heart. It was a perfect day for them. It ended well with laughter.

All three felt blessed to have each other in their lives.

Chapter 6

You only fail when you stop trying

Year 1999. They were in second year of their college.

Aashima— she was trying to work hard. She was pursuing Mass Communication, and competition was very tough in it. She had joined *Hindustan Times* as an intern. In her internship, she edited many articles, and there were many bylines published with her name in the newspaper, and she was appreciated for her work at the office as well as at home. She was happy and satisfied with herself. She always believed in one quotation:

"Stay positive, work hard and make it happen".

Karishma, on the other hand was enjoying her freedom in college. She felt as if she was a free bird flying on air, doing whatever she always wanted to do. Apart from studying, she was doing everything. She already had three re-appears in her first year and still her 'I don't care attitude was not going away.

Life was very good for her (that's what she used to think). She had made new friends, who according to her were 'super cool in today's slang. They taught her many things to do in

life like smoking, drinking, partying till late in night—and the list goes on.

Mahima, belonged to a very well-to-do family, and she lived in South Ex., And she was the girl to whom Karishma looked up to. She was a girl who used to come to college in car driven by driver, used to carry mobile phone (Nokia 5110 at that time), wore expensive branded clothes, and talked only about her trips abroad, and the brands she had. Her intellect was equal to zero. She didn't know anything that could help her pass her exams.

Karishma was impressed by her and always tried to follow her. She adored her dressing style, her fake accent, and her lifestyle.

She once brought at her house because she wanted to buy a mobile phone which Mahima had.

'Are you crazy?' Mr. Seth shouted at Karishma when Mahima left. 'Don't be stupid and think sensibly. We have an established business, and we haven't even thought of buying a mobile phone, and you are demanding it at just the age of eighteen?' Mr. Seth's temper was high.

'But, Papa! Mahima and my other two friends also have one. I want it too,' Karishma tried in crying tone.

'Krisha, tu pagal hogai hai? Are you in your senses?' Mrs. Seth asked Karishma with a strictness in her voice.

'Why? What's wrong with me?' Karishma replied in an irritated tone, as if she didn't want her mother to interfere in the matter.

'No means no. Why do you want a mobile phone?' Mr. Seth asked Karishma, to which she again gave the same answer: that her friends got it.

'Who are these friends? From how long do you know these girls? To my knowledge, Aashi and Siddhant were

your best friends, and I guess they don't have mobile phone, neither they want to have.' Mr. Seth was still angry. 'One more word from you, Krisha, about this mobile phone, I'll come to your college tomorrow to meet the teachers and will ask them to call your *rich friends* and their *parents*.' Mr. Seth's temper was at peak now.

'Oh please, Papa! Is it not enough that you want me insult in my college as well?' Karishma uttered these words out of anger. She ran to her room with tears in her eyes and locked herself in it.

Kids in this age don't understand what is right and what is wrong for them. They always demand some things that their friends have, without thinking if they really need it or not. The same was happening with Karishma, but she didn't talk about mobile phone at her home after this incident, not because she understood that she has no need of it, but she had this thing in her mind that her parents would not fulfil her any demand.

Karishma found it very difficult when her second year exams came; she had loads of assignments to submit. She realised she cannot do all these alone. She was very worried, she asked Mahima for help, but she said she has few parties to attend. Karishma couldn't believe that the one she depended so much on was not ready to help her when she needed.

Karishma started to stay awake all nights and then go to college the next morning. She started to become sleep deprived and lethargic.

Varun was noticing all these things, and he decided to help her sister. He helped her finish all her work. Karishma felt so relieved and relaxed that, yes, her brother was there for her.

Karishma never tried to take help from Ashima and Siddhant, who could also have helped her in just one call.

No matter how busy the would be, they would have never said no to her. But Karishma never realised their importance and never realised what she meant to both of them.

Varun also helped her complete her syllabus and she managed to pass with his help. Karishma realised that she didn't need a friend if she have a brother who will be there with her always. She started sharing her problems, her issues with him, and he gave her wise advices.

'Can I ask you something?' Varun asked Karishma as they were sitting in their balcony.

'Haan Bhai! What happened?' she asked.

'Why are you not talking to Aashi and Sid? They care for you so much,' Varun asked in a thinking mode.

'See, they and I have different thinking. They are still kids, dependent on their parents. I am an independent girl. I don't want to be friends with those who try to impose things on me and want me to do things according to them. Mahima also makes fun of them.' Karishma sounded as if this is a wrong topic to talk about with her.

'Is it about that mobile phone, Krisha?' Varun asked.

'Don't irritate me, bhai! Let's not talk about this right now.' Karishma sounded upset.

She left saying this.

Varun never really liked her new friends, but he couldn't do anything about it. He wanted to wait for the time when she really realises that she was wrong in choosing her new friends over old ones.

Karishma's college started again, and she forgot everything about what had happened. She was not even thankful to Varun. It was because of him that Karishma was able to clear her backlogs and manage to score satisfying percentage, but she forgot everything. She again started

going out with Mahima, trying to be part of something that she never really was. She was trying to be a second-rate version of somebody else then being a first-rate version of herself.

* * * * * Siddhant * * * * *

Meanwhile, Siddhant started composing songs for his band. He started performing his shows in events, college fests, restaurants etc. Although he was in a career that could give him good salary, decent job, and a settled life, he wanted to pursue his passion over career.

Sometimes life is almost risking everything for a dream, no one can see, But YOU!

He convinced his parents to give him some years to pursue his passion. He was sure that he could take it to another level. His parents showed confidence in him; they knew their son and how passionate he was and would achieve what he wanted to.

His hard work started paying off; his band was getting popular and famous day by day. His popularity among girls was also increasing. Girls adored his voice. People loved listening to him whenever he was on stage. He had a charm in his voice which could mellow down anybody. It was soothing.

Sonia, a girl from his college, started liking him a lot. She was his first fan—that's what she claims. She used to call him and always used to ask him out. Siddhant never entertained her and always made excuses.

Siddhant wanted to stay focussed on his road to glory. He was preparing for auditions for a show at Delhi Haat

on New Year's Eve, where various bands from the city were going to perform. He wanted his band to get selected and wanted to take it to the next level. He, along with his band members, worked very hard for that audition.

It was hard to get selected because few old bands that were well established and were more famous were also there, competing for same. Siddhant worked day and night for it, and yes, he got selected.

The judges remarked, 'We have never seen such a commitment and hard work which this new band has shown.'

Yes they made us learn to *just believe in your dreams. If you believe you can do it work for it, your hard work will pay.*

Chapter 7

Dreams turning into reality

Year 2000, we were entering in the twenty first century when both the clock hands were meeting at '12'. Y2K—as year 2000 was given this name—everyone was looking forward to it. Everyone had their plans for the occasion, some organised family get-together and prepared food for the same, some were having *pujas,* and some were having plans to booze and dance. Everybody had their own plans to celebrate it in their own way.

It was double celebration for Ashima as her brother, Ayushmaan, was coming back from USA. He was one year younger than her and was pursuing graduate studies from NYU, and he was coming back home for the winter break. Ashima and her brother shared a very strong bond. And the second reason for celebration for Ashima was because her best friend was going to finally live his dream. Siddhant was performing on a grand stage for the first time, and this was going to be his ticket to *fame.*

She called up Karishma when she reached home from the airport after picking her brother up, to remind her that

today they have to attend Siddhant's first concert at Delhi Haat.

'Karishma, just wanted to remind you that Sid is performing tonight. He would feel very happy if you'll be there,' Ashima told her quickly.

'Yes, yes! I'll join you, guys, I am leaving with Mahima for a party, but I'll leave early from the party and join you,' Karishma replied.

Ashima, Karishma, and Siddhant's had re-united few days back and Varun was the main person who helped the friends talk together before the New Year.

Meanwhile, Siddhant was preparing for his first big concert. He was excited as well as nervous. He was also waiting for Aashi and Karishma to come.

Varun, Ayushmaan, and Aashima left for Sid's concert. Ayushmaan was also looking forward to Siddhant's concert. Though he had come from a long journey, he didn't want to miss a big day in his life.

They all went to Siddhant's green room. Siddhant got so excited, and there was a huge smile on his face as he saw Ayushmaan after a long time. They met like two parted brothers and hugged each other and patted each other's back very hardly.

'How have you been?' Ayushmaan asked happily.

'Now I am good, when you all are here. But where is Karishma?'

Ashima told him that she has gone to a party but will join them before his performance starts.

Siddhant got a bit upset after hearing this because today was his big day, the day that they were talking about since their childhood, and when he was living his dream Karishma was not there.

He took out a packet of cigarette and started smoking. All others were shocked and started looking at each other.

'Is everything fine?' Varun asked Siddhant and patted his shoulder.

'Ya! Ya! I am fine, just relaxing myself. Don't worry, bhai, I don't smoke that often. It's just I am bit nervous.' Siddhant replied while lighting another cigarette.

'Aye recharge, boy!' Ayushmaan jokingly said to lighten up the atmosphere. They spent time in the green room, joking and remembering old days.

Yes, Siddhant was laughing and cracking jokes with everybody, but Ashima could sense a sadness in his eyes and voice. He was trying to hide his tears with the smoke of cigarettes, but it's difficult to hide feelings from a true friend.

A friend is someone who can see the truth and pain in you even when you are fooling everyone else.

It was 10.30 p.m., and Siddhant's performance was about to start in half an hour. Ashima started calling Karishma on Mahima's phone. Around eleven, Mahima answered the call and told that Karishma was with her boyfriend and she left long ago with him. Ashima didn't wanted to tell this to Siddhant. She told him that she will be late and asked him to get ready for his performance. Ashima was surprised to know that Karishma was dating again and she never told any of them.

Siddhant was on the stage, holding a guitar in his hand. He was standing still and was looking at the crowd. He was living the dream, which he had dreamt. People were cheering for him, chanting his and his band's name. With a big smile on his face, Siddhant suddenly hit the chord of his guitar and, 'Woo!' The entire crowd just wooed back

and started shouting, and Siddhant's band started their performance. He was happy that everybody was enjoying and his friends were present there in the front row cheering for him. It was the happiest day for him.

Ashima was feeling nostalgic. She was very happy that her best friend is living up his dream. Meanwhile Karishma was with her secret boyfriend whom she was dating for the last two months. She wasn't bothered about what her childhood friend would feel and didn't even think of showing up to the venue of the concert; instead she was busy partying with her new friends and this secret boyfriend.

She was high on booze and went with her boyfriend to his rented room in Uttam Nagar. The boy whom Karishma was dating this time was from Meerut. She met him few months back in a party. Mahima introduced him to her, and they immediately clicked and started to meet more often.

The moment they entered into his room, Karishma's mysterious boyfriend started kissing her. He grabbed her in his arms and placed his lips on hers. Karishma was all boozed up, and she was enjoying each and every bit she was spending with her man. She started biting his lips with her hands on his back, and started caressing it.

He took her to his bed while kissing her, and they both fell on it.

He was lying over her and was sucking her lips and kissing her cheeks. Karishma was responding to him completely. She unbuttoned his shirt's few buttons and started caressing his chest. This act turned him on more; he started and kissing her more wildly and started lifting her top up. Soon, they were wearing nothing on the top, and Krisha was over her guy. Her lacy bra was lying on the floor with her top and his shirt.

'I have never felt that good!' Karishma told her boyfriend with her head on his bare chest. They both were lying naked on the bed with a thin blanket over them.

'Even I have this same feeling!' he replied and kissed Karishma's forehead. Did you really like it?' he asked Karishma.

'I loved it!' she replied and placed a kiss on his lips.

'Want to have one more round?' he asked Karishma in a naughty tone with a smirk on his face.

'You don't have to ask me this.' And she was over him again after replying. Karishma was still neither worried about reaching home late nor bothered that her best friends were waiting for her.

Siddhant was playing his last song of the evening; he chose 'Dekho 2000 Zamana Aa Gaya', from the movie *Mela*, to perform in his own version. People were loving it and dancing like crazy. Soon the band concert was converted to a jam session, and everybody was jamming on Siddhant's tunes and the moment the clock stuck twelve, everybody started hooting, whistling, and shouting, 'Happy New Year!'

The entire crowd was praising Siddhant's and his band's performance. That show was a great hit, and he was very happy.

Chapter 8

Clarifications

New Year, new day, and it started off with a phone ringing again at Aashima's house. It was Karishma who was calling her again and again, and Aashima did not feel like talking to her because of what she did the previous night.

In the evening, Ayushmaan and Ashima were sitting together, with his luggage opened. He was showing his sister what stuff he got for her and others. Suddenly, doorbell rang; it was Karishma on the door.

'Why the hell you are not picking up your phone? Are you still alive and living on this planet?' Karishma entered, shouting these questions in bit high pitch. 'Oh! Is that Ayushmaan? Oh my god! Dude, you are here! Wow! What a surprise, man!' Karishma got her pitch back to normal when she saw Ayushmaan.

'Krisha, I told you that he is coming back home for this New Year couple of days back. You must have forgotten.' Ashima was irritated with herm and it was heard in her tone as well.

'Oh! You told me,' Karishma replied, surprised, scratching her head and trying to think. 'Anyways, Aashi, can we talk? Let's go for a walk for ten minutes only.'

They went outside, and Karishma was feeling sorry that she did not tell anything to her before.

'Are you upset with me, Aashi?' she asked in an enquiring tone.

'Why should I be?' Ashima replied in a sarcastic tone.

'Whatever, I am sorry. I know it's wrong on my part, but please try and understand me.' Karishma tried to explain herself.

'Don't apologise, Karishma, I cannot force you to tell me everything. It's totally your choice with whom you want to share your personal life, and for that nobody can force you, not even me.' Ashima tried to explain her that it's her life and her decisions. She has no role in it.

'Achcha, listen, Aashi, I met this guy two months before in a party with Mahima. She pushed me to talk to him as he seems to be nice smart and well-of guy. He is from Meerut and is living in Uttam Nagar in a rented flat. I was with him whole night yesterday, and I was so high that I couldn't turn up. You know we both were so high and we came very close. Fuck, man. I really love him.' Karishma sounded in love.

Ashima listened and didn't react the way she wanted to, but she was afraid where Krisha was going. Falling in love so quickly was like her hobby now. Moreover, this guy, she just met him and didn't know much about him as well. Any how that's how she was.

Ashima listened to her and tried a last tie to explain her few things which could be helpful for her in future. 'See Karishma, life is not so easy as it seems to be in college.

College life will be over in a year, then, what will you do? Have you ever thought about it?'

She further added 'If you want something that you never had, You have to do something you've never done'

'I understand Ashi, I know all this, I am not kid. I know how to balance out career and lovelife, don't worry at all' Karishma tried to explain Ashima she knows everything and she is wasting her time in explaining those things to her.

Chapter 9

Reunion

It had been almost two months, since the day the three best friends hadn't met.

Siddhant and his band were performing at Central Park, Connaught Place; the organisers had booked them to perform on Valentine's Day event. Siddhant had always dreamt that whenever he was performing, he wanted his best friends to be there with him, supporting and cheering. But this time none of them knew that he was performing in an event. He was missing both of them so much. He wanted them to be there with him. He was constantly thinking of how can he reunite all of them and bring the old days back.

After his show, he thought of using the good old technique of calling both his friends, one by one, to a place, without telling them that he has called the other person also. As if he had told Ashima that Karishma was coming, she would have never agreed to come.

He picked Wimpy's, Connaught Place, as the venue and asked his two best friends to reach there by noon.

Ashima reached early and she saw Siddhant standing at a cigarette shop outside Wimpy's, and was having his *sutta*. The moment he saw Aashima coming, he threw away his cigarette, not because he was scared that Ashima would yell or nag him; it was because he knows that she feels uncomfortable and suffocated because of the cigarette.

'Chodh de kutte!' Aashima shouted with a smile on her face as she saw Siddhant throwing his cigarette while he was heading towards her.

'Finally!' Siddhant was super excited and happy to see her. He hugged her with a constant big smile on his face.

Both of them went inside the restaurant, took a table, and started talking. Their table was adjacent to the big window from which you can see Janpath, Jeevan Bharthi Building and crowd crossing roads and going here and there.

While Ashima was talking to Siddhant, she noticed a familiar face crossing the road; and out of shock, she called her name, 'Oh my God, Krisha!' Yes, she noticed Karishma and gave a look at Siddhant. He asked her to be calm. But both of them were surprised, when they saw Karishma coming along with a guy.

'Is she holding that guy's hand?' Siddhant asked Ashima, doubting his own eyes.

'Yes, she is! Wow! Great!. Did she tell you that she'll come with someone?' Ashima asked him.

'No! Not at all.' Siddhant sounded angry.

'Hmm, leave that! We all are meeting and going to sit together after such a long time, let's not spoil it. Leave your anger, don't show you are bothered, and just smile.' Ashima tried to calm Siddhant down.

After that talk they had none of them had tried talking to each other. Ashima was missing Karishma. But finally she

was meeting her best friend, whom she was missing from past so many days and was happy with the fact that the 'three best friends' were going to be together again.

Both Ashima and Siddhant were staring at that guy. He was a tall guy with a fair complexion, wearing a black-coloured 'Monte Carlo' sweatshirt with blue jeans. He was not a handsome guy, but yes, he was smart.

'Oh hi, Aashi! I didn't expect you to be here. Anyways, how are you, dear?' Karishma's tone was bit sarcastic and Ashima realised that she was not that happy to see her as she was.

This statement made Ashima upset. She wanted to stand up and leave that place at the very same moment, but Siddhant stopped her and she remained seated.

Karishma's boyfriend shook hands with Siddhant and Ashima and sat beside Karishma. There was some sort of bad vibe coming from Karishma's boyfriend, which was felt by both Ashima and Siddhant. His eyes were scanning Ashima. She could feel his constant lusty stare, which was making her uncomfortable sitting there.

'So, Sid, Kishi baby was telling me that you have a band and you sing, how is it all going?' It was the first time when Karishma's boyfriend took his eyes off Ashima and started talking to Siddhant.

'Everything is going good, brother right now I am working on establishing the name of the band' Siddhant answered them back.

Siddhant was feeling uncomfortable sitting there so, he took out his packet of cigarette and told them he's coming back in five minutes and he went outside.

'Where has he gone? Is he fine?' Karishma asked Ashima in an animated tone.

'He must have gone to smoke. He is smoking a lot these days,' Ashima replied with a worry in her voice.

'What are you saying? He has started smoking, but why?' Karishma was shocked.

'Arre he is a singer yaar. These people lead their lives like this only. It's like fashion or style symbol for these people. I am sure he is into drugs also.' Her boyfriend jumped immediately between Karishma and Ashima's conversation and gave his expert comments.

Ashima was amazed at what that guy was talking about and of Karishma was agreeing with him. She was glad Sid was not there.

Siddhant was back, and their order was ready too. Ashima got up to take the other. She felt a very strange vibe; she caught Karishma's boyfriend checking her out from top to bottom with same lust in his eyes. She was very uncomfortable. She wanted to tell this to Karishma, but Karishma was lost in her own world, blinded by her love for her boyfriend and could not see or feel anything. She couldn't even realise that Ashima and Siddhant were getting conscious of the fact that her boyfriend was not behaving in a decent manner.

'So what do you do?' asked Ashima in a judging tone from Karishma's boyfriend.

'I am pursuing Company Secretariat, CS second year student,' replied her boyfriend with those lusty and degenerated eyes staring and glancing Ashima again.

'Oh CS! What are your subjects? What do you plan to do?' Ashima asked with bit of anger in her voice and eyes.

'Actually, this is my third attempt for CS. I hope to pass my second year and I have lots of subject,' he replied without making any eye contact this time.

Ashima and Siddhant gave each other a look after the mention of third attempt and he didn't even know his subjects. They both knew that they are thinking the same thing: that it won't be impossible for him to clear this time also then.

'So, where is your permanent house? What's your dad's occupation? What if you don't clear CS?' And Ashima went on interviewing him and judging him.

Karishma could see Ashima questioning her boyfriend a lot. She was getting irritated, so she asked Ashima to relax a little and stop her rapid-fire questions.

Ashima didn't utter a word after that and sat quietly, and still she could feel those lusty eyes of Karishma's pervert boyfriend checking her out.

'I am going to order one more coffee for me. Anybody interested?' Ashima asked everybody and went to place her order as everybody nodded to her offer. She then went to the counter.

Karishma's boyfriend also went behind her saying that he also wants to add a cold coffee for himself. He went and stood behind Ashima and started staring at her from behind.

The moment Ashima turned around, she saw him staring at her and asked him what he was doing there.

'Nothing, Just came to place my order for cold coffee' He replied in a casual tone.

That was it for Ashima. She said, 'Don't you dare MR. I know what you are up to. But let me tell you such things never work on me. I know how to handle guys like you. Don't you dare to break Krisha's heart, understand? Stay away from her. She doesn't deserve a cheap imitation of a "good guy". Perverts like you deserve none, and you better

stay in your limits with me.' She pushed him a little and went back to the table.

'What happened?' Siddhant asked Ashima when she came back in anger and sat down making a face which he had never seen.

Karishma's boyfriend also came back and sat, but now he was not talking much; he was mum. Now he did not even dare to look at Ashima. Karishma could sense that something was wrong with her man.

Yes, all three of them came together after a period of time, but still a lot was there to say. They bid one another goodbye and left.

On the way back, Karishma's boyfriend was quiet. He was not uttering a word. She asked him what happened, what was wrong, what was bothering him and all other such questions.

'No nothing, just like that! Let's go home,' he replied, showing very clearly that something was wrong.

'Please tell yaar! Were you bored? Don't be upset with my friends. We will not talk to them if you are not comfortable.' Karishma was going on and on, making him realise that he was more important to her than anybody else.

'No, I liked them. It's just that I don't know why she didn't like me,' he said.

'Did Aashi say something to you?' Karishma abruptly asked him.

'No, no nothing like that. But if they have problem with me, we can think about "us" again' he replied in a fake sad tone.

'What did she say to you? Tell me.' Karishma knew she Ashima said something for sure.

'Well, if you insist . . . she asked me to stay away from you, which though is very hard, but if she doesn't like me, we

can stop talking. After all, they are your childhood friends.' He was trying to act innocent and on other hand filling Karishma's ears against her friend by not telling her the truth.

Karishma was so blinded by her love for him. 'Sweetheart, don't mind her words, she tends to be jealous of me. She must have seen that you are a smart guy, so she must have wanted to increase our gap by saying all this. I'll look into this matter. You don't worry and don't get upset with what she said. Just forget it.' Karishma said so many ill things about Ashima.

Karishma's boyfriend dropped her at Miya Wali's bus stand. She gave him a little hug, and he left. Karishma was very angry on Ashima and she decided to confront her and went directly to her house.

Aashi was sitting in her house's veranda, thinking how to protect Karishma from this guy. Can she do anything? As she was busy with her thoughts, she saw Karishma coming to her house.

'I was thinking about you only and was planning to come to your house, Krisha. I want to talk about something. Come and sit and tell me. Will you have Maggi and cold coffee? Mom is making some for me?' Ashima asked her.

'Aashi, I haven't come here to sit or to have Maggi with you. Just wanted to ask why did you warn my boyfriend to stay away from me? What's wrong with you?' Karishma was very angry and was shouting.

'Krisha, listen to me, why in this world you are shouting? Trust me, he is not good for you. You first sit and I will tell you what happened. You relax first,' Ashima told her and was holding her arm.

'No, thank you Aashi. I had enough of you. Just stay away from me and my life. Don't you dare interfere into my

matters or between me and my boyfriend again, understand? I know you are jealous, but how could you get that low? I've never expected. Just stay away from me.' Karishma said these words out of her anger.

Ashima was shocked and surprised, hearing such things from her childhood friend, whom she was worried about few minutes back. And before she could explain herself, Karishma left.

She was at a loss for words that it was her best friend who said all that to her and did not trust her. It was that best friend who wrote in card, *'If one day you feel like crying, call me. I can't promise to make you laugh but I am willing to cry with you.'*

And that day it was she who made her cry. Ashima had tears in her eyes. She went in her room and opened her treasure box that had her childhood pics, greeting cards, which Karishma and Siddhant had given her.

She spent hours looking at those pictures, remembering good old times and wondering how a guy could be so important for Karishma that she forgot the time they spent together.

My best friend doesn't realise how much I need her. This was the only thought that was going on and on in Ashima's head.

Ashima remained quiet and didn't talk much with anybody. Yes, she was heartbroken, but life goes on.

Meanwhile, Siddhant and his band had to perform at Ansal Plaza, Delhi's first mall. He was in his green room thinking about Karishma. He was troubled with what she was doing with her life and why.

While he was performing on the stage, he saw a guy sitting on a bench with a girl. The guy looked familiar. Siddhant was trying hard to think that who that guy was.

Yes, it was Karishma's boyfriend with some other girl. He was cuddling her, was moving his hands over her body, and was trying to kiss her.

Siddhant's performance was over, and DJ K2 took over the crowd with his remix tracks. Siddhant rushed immediately to the phone to call Karishma at her house.

'She is not at home, Sid,' Mrs. Seth replied.

He called Mahima's number, and yes, she was with her.

'Where is your boyfriend, Karishma?' he asked her, not even saying hi.

'He has gone for two days to his hometown. Why are you asking this, Sid?' she asked in wonder.

'No, Krisha, he is a liar, he is here with a girl, at Ansal Plaza. If you don't trust me, come and see with your own eyes.' Siddhant hung up the call.

Karishma was at Sarojini Nagar Market with Mahima and her gang for some shopping. It took her half an hour to reach Ansal Plaza. Siddhant was back on the stage with DJ K2, and they were performing together. She searched the whole venue but couldn't find her boyfriend. Now she got angry. She thought with her little brains that Ashima and Siddhant were trying to make her break up from her boyfriend so that Ashima gets a chance.

Sid finished his performance and came to Karishma and asked her did she saw him or not.

Krisha very angrily replied, 'See, Sid, I don't know what you and Ashima are up to, but let me tell you one thing very clearly: that I love my boyfriend and there are no chances of us breaking up. I can smell what you both are up to. She won't be getting him in any case. So better behave and stay away from me and my life. I had enough of you guys trying to spoil my life.' And she left without even listening to Sid.

Sometimes you have to decide whether it's worth turning the page or whether it's time to close the book.

Both Siddhant and Ashima decided to close the chapter of girl called Karishma in their life and moved on. It was hard for them, but they decided to wait for her to realise her mistake.

Chapter 10

Every day is a chance to change your life

Year 2003—Karishma, Siddhant, and Ashima graduated. With big dreams in their eyes and loads of plans for their future, they were stepping out from there colleges.

Karishma wanted to study more; she wanted to pursue post-graduate studies, and the course that she opted for was MBA. Corporate world always fascinated her, and she always wanted to get into finance field. She took admission in a reputed and good college of Delhi. She was still dating the same guy, and yes, she was blindly in love with him.

Ashima on the other hand got placed in Aaj Tak. She had started going to Videocon Tower at Jhandewalan. She joined them as an editor. She used to edit news reports that are to be telecasted as special programs on their channel. Besides this, she was also writing articles for a magazine as a freelancer. She wanted to be a independent girl who has a good and a well-settled career. She was happy and satisfied with what she was doing in her life.

Siddhant always knew that he was made for music. Music was his life, so without any second thought, he

started giving his 100 per cent effort and time into singing and music. He, with his band, was working on new songs, covering as many shows or events that they can, just to establish their name in the crowd. He was also trying his luck to get a break as a solo singer as well.

'If you can dream it, you can do it.' These words by Walt Disney were like a mantra for Siddhant, which he had been chanting since he began to be in the race of making his name in singing. His grandmother also said him once that 'you cannot stop thinking about it, don't stop working for it.' And this was what he was doing. He wanted his fame, and he was ready to face anything and everything in getting it. All three were busy in their own personal and professional lives.

'What is it? Tell me, sweetheart.' It was Karishma, who was blindfolded by her boyfriend, who took her to his room to give her some surprise.

'Just two minutes, Kishi baby. Don't you trust me?' He was talking in a childish and pampering tone while he was opening his room's door.

'Okay! Now you can open your eyes,' he asked Karishma while taking off her blindfold.

The room was lightened up with candles all around and fragrance of nice room freshener was coming. There was a table with a nice linen, over which a candle was placed. There were two wineglasses and a bottle of Amarula, with food dishes kept on a trolley next to the table.

Krisha was awestruck. She had no words to express how she was feeling after seeing all this. It was the best thing anyone ever did for her. She had seen all this in movies only and always dreamt that her 'Mr. Perfect' would do something like this for her. It was like she has found her dream guy and now she never wanted anybody else.

'Oh my God! I have no words, baby! This is so *exquisite*! Thank you for doing this, baby. I am feeling very special.' She was happy and touched.

'Shhhhhh!! You don't have to think like that, you are special to me, and I'll do every thing to make you feel more special. Now, may I have a pleasure of having a candlelight dinner with the most beautiful girl I've ever seen?' He pulled out one chair and asked her to sit with a smile on his face. He was doing everything to make her feel special, and Karishma was mesmerised with all this.

He put on some instrumental romantic songs on his music system in the background. What else could she need? Romantic candlelight dinner with your love and romantic music in the background, Karishma was glowing with love. She has never felt that special.

'How's the food? Did you like it? I prepared it for you,' he asked Karishma while sipping his wine.

'Really awesome! I didn't know that you are such a good cook. I am impressed,' Karishma replied and winked at him.

They had their food and drinks and discussed many things. They even talked about their future and decided that within two years they'll marry—by the time Karishma will be done with her post-graduate studies.

'So, what's for dessert?' Karishma asked in a naughty tone after they finished their food and drinks.

'You can have me, and I can have you,' he replied in a seductive tone and lusty eyes, while moving his feet over her legs under the table.

'I have one more surprise for you.' He continued talking, while his feet still caressed her legs.

'What is it now?' Karishma sounded excited.

He got up and got a dress for her from his closet and asked her to try it on. It was a small skirt with a halter top. Karishma gave a naughty smile and went to try it. The moment she came back wearing those clothes, her boyfriend's jaw dropped. She was looking so *hot* and *sexy*.

She started walking slowly towards her boyfriend who was sitting on the same chair beside the dinner table. She was biting her lips and was playing with her curls; she was so seductive at that moment, and her boyfriend was looking at her with lust in his eyes.

'Let me have my dessert.' Karishma spoke in a husky and seductive voice and sat on his lap, facing him, and placed her lips on his. Yes, she was kissing him very passionately.

Her boyfriend was responding and was kissing her back, with his hand on her legs and thighs. After few minutes of kissing, he stood up, holding Karishma in his arms, and went to his bed. He dropped her from his arms on the soft mattresses and lay over her. Karishma was so much in love with him that now she could not see anybody in her life, except him.

After the whole pleasure exercise, she asked him to drop her off as she was already very late. He took his car keys and drove her home. She kissed him on his cheeks and lips while getting out of the car and bid him goodbye.

It was very late at night and she was not worried how she will face her parents. Varun was in the balcony and saw her coming; he immediately went downstairs to open the gate before she could ring the doorbell.

'Have you seen the time?' Varun asked her angrily but in a low pitch.

'Bhai, I was—' She was about to make an excuse when Varun interrupted her, saying he knew where she is coming

from. He asked her to go to her room quickly. He didn't want her parents to see her coming this late in the night as they have already slept and Varun has already made an excuse that she'll be coming bit late as she has gone to Ashima's place for some help in her project. She quietly went to her room.

Varun went to her room to talk. 'Karishma, he is not a good guy. I have heard a lot about him, why don't you trust anybody?'

'Bhai, I don't interfere in your matters, and I expect the same. I hope you understand. I don't really care what everybody thinks about him.' She was extremely firm and direct, which led Varun to leave her room as he knew that she'll not listen to him, and it's not worth make her understand as her eyes were all covered with the smoke of love. She had made up her mind, which nobody could change.

The next three days, Karishma tried calling him at his room, but nobody was answering the calls. She even went to his room once, but it was locked. She was tensed and worried for him. She even asked one or two of his friends about him, but they also didn't know where he was.

After three days, Karishma received a call from him, and she was relieved to hear his voice after that long.

'Hi, Karishma! I know you would be upset with me, but there is something really important I want to tell you. Listen carefully and deal with it maturely.'

Karishma got nervous after hearing this and asked him to continue what he was saying.

'See, Karishma, I am five years older than you, and I flunked in my CS exams again. My father asked me to return home immediately and has asked me to join our family business. They don't want me to waste any more time

on studies as I am already twenty-seven and still not done with my studies. They want me to join the business and get married. They have even looked for a girl and had already committed to her parents. I have to marry her now as I have no option now. Deal with it maturely and accept it. Nothing can be done now as I have no degree and can have no job. The only option left to me is joining my dad's business. I am going back Meerut, and I'll be getting married soon. You are a nice girl, and, don't be upset with all this. I am sorry. Bye.' He disconnected the call, and Karishma was shocked.

She could not believe what had just happened. Few days back, everything in her life was so beautiful, everything was so perfect and was going very smoothly; and now that bubble of perfect life just *popped*. She was helpless. She had no way to contact that guy now. No number no address.

She pinched herself, but no, it wasn't her dream; it was reality, and she had no option but to accept it.

She went inside her room, closed it, and stated throwing books, pillows, soft toys, and everything she could and started crying loudly.

'How can he do this? I can't believe. He can't go, he can't leave me like this. I gave him everything, and he left me. What will I do now, my life is waste.' She was repeating herself again and again while crying.

She started staying in her room, crying the whole day and the whole night. She was not ready to accept the reality, that the 'love of her life' had left her and would not be coming back again.

Whenever she heard her phone ringing, she rushed to pick it up in hopes that her boyfriend was calling her and he'd say that living without her was not possible, so he was back. But no call came.

She even stopped going to her college. Varun tried to talk to her several times, but she refused to talk. She just wanted to live in her dreams and did not want to accept the reality that her true love has gone forever.

It's very true that '*one of the hardest things to do in life is letting go of what you thought was real.*'

It took an entire month for her to get back to normal. She might have not forgotten him, but she was trying to move on in life. She started going to her college again and was trying hard diverting her mind towards studies.

She went to District Centre, Janakpuri, after her college to pick a project from a shop. As she was looking for an auto, she thought she saw her boyfriend's car parked in the parking. Yes, it was his car, and suddenly, there was a smile on her face. She thought he might have come back from Meerut for her. She started looking for him all around the place.

Tired, she came back and sat near the car and started waiting for him there only. After an hour-long wait, she saw him coming. She was about to run towards him, but she stopped suddenly. He was coming with a girl from her college, hand in hand, and they were looking as a cute couple who are madly in love with each other.

Karishma froze and didn't know what to do. Her hands became very cold. All things came as a flashbacks in her memory, like a movie running in front of her eyes.

VARUN: *He is not a good guy Krisha.*

SID: *He is here with a girl.*

AASHI: *Stay away from Krisha.*

All these words were echoing in her ears. She realised how wrong she was. She didn't listen to people who cared

for her. She managed to run away from there and took an auto for Mia Wali Nagar.

The whole way she was thinking how wrong she was. She said so many wrong things to her childhood friends and didn't even trust her own brother. They all wanted was for her to be safe. They could see what she couldn't.

'Oh! What have I done? How will I face them now? What will they think of me?' She was getting very nervous thinking all these. Worried and tensed, she was talking to herself that she was such a fool.

Tears were rolling down her eyes, and she kept on wiping them off. She was cursing herself about why she had let him ruin her life. She was broken. She wanted somebody to console her, and she decided to go to Ashima. She knew that Ashima will forgive her and she'd help her come out of this situation.

Chapter 11

Life is tough my darling, but so are you

Karishma ran straight away to Ashima's house, as soon as she got down from the auto. She was all in tears and wanted to see her best friend. Thoughts like 'What if Ashima refuses to meet me? What if she'll not talk to me?' were going in her mind.

She rang Ashima's doorbell, and it was Ashima who opened the door. Karishma broke down the moment she saw her best friend. She started crying loudly and hugged her tightly.

'I am so sorry Aashi. Please forgive me, please. I am very bad. I hurt you all the time. I was wrong about my decisions, and my behaviour was really very bad. I am very sorry. Please! Please! Please! Forgive me, please, I need you' Karishma was crying very badly.

'Relax, Krisha! Please stop crying. Calm down, What happened?' Ashima told her with her hand on her head and tried to calm her down. She took Karishma inside her room and brought a glass of water, which she gulped down in a single sip.

'I am so sorry, Aashi. Please forgive me. What you have you been thinking about me? What has Sid been thinking about me? What kind of girl am I? Shit! I have done so many blunders. Please! Please forgive me, I am begging,' Karishma said, still sobbing.

'What happened tell me? And don't be bothered what we think about you. We haven't made any opinions about you, we haven't changed our perception towards you. You are the same old Krisha for us, nothing has changed.' Ashima told her by keeping her palm over her hand.

'No, I know you are lying. What you have you been thinking of me? But I was blinded by his love. I was not able to think what was right and what was wrong for me. I should have listened to you guys. Such a fool am I.' Karishma was still sobbing.

'Karishma! It's all right. We are the same, dear, nothing has changed. You should trust us. We are your friends, not your enemies. We would never tell or do anything that is wrong for you. I don't know who has injected this thing in your brain that we were jealous of you.' Ashima was trying to explain and clear things in Karishma's mind.

'No, it's not like that, Aashi, I am very sorry. I behaved very wrongly and very rudely with you and Sid. Oh my God! What had Sid been thinking about me?' Karishma sounded worried.

'Please, Krisha, don't you worry what we think. It's opposite. What you think about us is more important. You should know that we are your well-wishers, we'll never think ill of you. We love you, and we are not supposed to show you what we feel every time, you should understand that. In life, you face so many situations where you have to take a decision, a decision that could be right or wrong. You are

capable enough to differentiate between *black* and *white*, the same way you can see what is a right decision for you and what is wrong. If you are not able to understand, listen to your brother, he loves you. And yes, we are here to guide you, but at the end of the day, it would be your decision.'

'I understand, Aashi, but you've probably been thinking how mean I am.' Karishma was all concerned about 'What do Ashima and Sid think about me?'

Ashima was getting annoyed listening to the same thing again and again. She wanted her to understand that she feels the same for her like the good old days, but Karishma was in her own pity party.

'Let's cheer you up! Come, get up. Let's go to Jawalaheri Market. I have to buy some *kurtis* for my office. Help me in getting the latest fashion, and we'll have gol gappas as well.' Ashima tried to cheer her up and took her out, holding her hand.

On their way to the market, Ashima started to talk about their childhood, remembering good old days with no worries and no tensions.

Karishma was happy after a long time. She realised *that she is her best friend. Sometimes we have problems, sometimes we fight, sometimes we cry, but I know everything about her and she knows everything about me, and even though we have flaws, we love each other and we'll not stop doing that ever.* She was glad that her friend is there with her no matter what happens in life.

They spent a lot of time together. They did shopping, they had gol gappas just like their childhood days.

After Jawalaheri Market, they came back to Karishma's house, and her parents were so happy to see Ashima coming to their place after such a long time. They haven't seen

Karishma that happy in the past few months. Seeing her smiling, giggling, and talking made them feel relaxed. Ashima told Krisha, 'Remember, life is tough but so you are, so, Don't ever give up'.

Both Ashima and Karishma decided to call Siddhant and put the phone on speaker so that all of them could talk simultaneously.

'Let's meet together tomorrow at McDonalds, CP,' Karishma said while they were talking on the phone.

Siddhant had no other option but to say, 'Yes.'

Ashima had to go to a family function, so it was not possible for her to join, but she asked Siddhant and Karishma to not to cancel the plan. So, Karishma and Siddhant decided to meet by 1:00 p.m. in McDonalds.

Karishma reached McDonalds early. She grabbed a table and was waiting for Siddhant.

'SIIID! Over here!' Karishma screamed and waved her hand the moment she saw Siddhant entering the restaurant. Yes, she was very happy to see him.

Siddhant gave her a cold smile, showing that he was still upset with her. He wanted to tell her that coming, going, and not believing them—she cannot do this all the time. He was even more upset with the things which she had said to Ashima.

He wanted to tell her that it was her choice if she wanted to believe in them or not, but she had no right to put judgements and accuse them with unfounded allegations. Even they could get hurt; she cannot always just come back and say sorry and then don't realise that she had done wrong to them. All she cared was 'What will they think about me' and not 'How much I have hurt them.'

'Oye, Sid! Why are you giving me a fake smile?' Karishma asked, bringing Siddhant back from his thoughts.

'Nothing, Krisha. How are you?' Siddhant tried to change the topic.

'Yaar, I am so sorry. Why are you changing the topic? Sid, please you know I was not thinking in a right direction. Why are you talking to me like this, yaar? Please, I cannot take it you talking to me rudely.' Karishma was troubled and was trying to give all sorts of excuses she could.

'Nothing to worry, Krisha. I was just upset with what you said to Aashi. You should not have talked to her like that. She felt very bad.' Siddhant sounded upset.

'Sid, see I don't know what she had told you, but now things are fine with us, so you should also relax.' Karishma was irritated now.

'Hmm, yaa, leave it. Even I don't want to extend this topic now.'

'Sid, how's your shows and performances going on?' Karishma tried to change the topic now.

'Good!' Siddhant replied in an annoyed tone.

'Why are you talking like this, Sid? I have gone through a very bad breakup. Instead of sympathising with me, you are trying to make me feel guilty now. Stop it!' Karishma was pissed off with Siddhant now.

'Okay, leave it, you can never understand what I want to say. Anyways, how's Varun and everybody at home?' Siddhant gave another try in changing the topic.

'They are fine. Can you believe Varun has the same girlfriend from past so many years?' Karishma said.

'That's nothing to be amazed of Krisha. It's called commitment,' Siddhant replied in a taunting manner.

'Hmmmm . . . I know that, Sid.' Karishma had enough of him now. She sat quietly after that and gave little little

inputs to whatever they were talking about. Siddhant was also noticing this, but he did not say anything to her.

After they were done with their meal, Siddhant asked Karishma, 'Want to go out for a smoke?'

Karishma nodded her head in yes.

'Bhaiya, two Classic Regular,' Siddhant asked the panwari outside and lit the cigarettes.

'Wow! You have become a *pro*, man! Look at you making smoke rings, exhaling smoke out of your nose. Kya baat hai!' Karishma tried to lighten up the mood by adoring Siddhant's way of smoking cigarette.

Siddhant gave a smile and patted her shoulder and asked her to move. It was time to return home.

Chapter 12

The new chapter in Ashima's Life

Family functions—an occasion where all uncles would be drinking like a tanker and using swear words, especially in a Punjabi function. You'll see group of uncles standing beside a table with snacks and drinks on it, with a waiter standing beside them, listening to each and every order of them.

And then there were 'gossip, all the ladies in the house. Ladies' groups are divided into categories—mothers-in-law gossiping about their sons 'wife, and daughters-in-law taking about their husbands' mother. You can often see ladies of both the categories giving tips to mothers who have an eligible son for marriage and to an unmarried girl.

Guys in the functions stay busy in sneaking to a place where they could gulp their quarter, which they have bought just before reaching the venue, and lighting a cigarette without anybody noticing. And when somebody asks them, 'Where were you?' the most common excuse they use: 'Bathroom' while chewing Center-Fresh.

So Ashima was there at such a function with her parents; it was her cousin's wedding. They all were very excited as

they were going to meet all their relatives and family friends there.

Ashima was wearing a red-coloured suit. The way people were adoring, praising and looking at her, she was convinced that 'yes, I am looking pretty.' She saw various aunties in the function, scanning girls top to bottom for their eligible, unmarried sons. She could hear those aunties talking and commenting about over girls in their high-pitched Punjabi tone.

Ashima's dad called her as he wanted her to meet one of his old family friend, Mr. Khurana, and his family. They were seeing Ashima after a very long period of time.

'Oh my god! She is so grown-up, and she is looking so pretty.' Mrs. Khurana was awed the moment she saw Ashima.

'Namaste, Aunty! Namaste, Uncle! How are you?' Ashima greeted them. Asking 'How are you?' is a formal way of starting a conversation. They asked her how she was, what she was doing, and some other random questions.

'Khurana, Where is your son? Is he back?' Ashima's dad asked his friend about his son.

'Yes, yes he has come for sometime. He must just be here only. There he is!' And Mr. Khurana shouted his son's name to call him, 'PALASH!'

Palash was a tall and smart-looking guy. He was wearing black suit with a white shirt. He came where his parents and Ashima's parents were standing and greeted them by touching their feet. He told them that he was working as a software developer at Applied Materials, located in Silicon Valley, USA, after completing his studies over there.

Ashima was impressed by the way he talked. He was very polite and humble. He was a perfect guy who can be liked

by anybody who loves simplicity, and Ashima was amongst those. While he was talking, Ashima felt something ; even Palash was looking again and again at her too, and both of them felt a connection to each other.

After a while, Ashima's dad left with Palash's dad, and their moms started taking to other aunties in the party, leaving the two alone. They started roaming around the food stalls.

'So, United States, what exactly do you do there?' Ashima broke the silence by and asked him about his work.

'I have all the software things to do, and plus I do a little time pass also' he replied in a comic way just to make the talks little cheerful.

'Ha ha ha! Ok'

'Even my brother is studying in NYU. He is taking Business Administration as his major.' She further told him.

'NYU! That's great. I did my MS from San Jose State University, California. Your brother is in a very good university, and it's fun living in or near New York, shandaar jagah hai!' He sounded comfortable talking to her now; at least they have something to talk about now. 'You are working in some news channel, right?' he asked Ashima

'Yes! I am working as an editor in Aaj Tak channel and also write articles for *India Today* magazine as a freelancer,' Ashima replied with a smile on her face.

'So, do you have any boyfriend or had any?' He asked Aashima.

'No! No! Never! No guy has approached me ever. I guess I am too ugly,' she replied. She deliberately used the word *ugly* as she wanted the guy to praise her; she was loving his company.

'*Ugly?* I think guys around you must be blind as they are unable to see such a pretty and beautiful girl.' Yes, he praised

her, not directly, but yes he complimented her, which she took with a shy smile and red cheeks.

They started talking of various topics now. They were discussing about their work, USA, Indian marriages, people who were there in the marriage, and loads of other things.

Palash's mother was talking to his father when she saw Ashima and Palash standing and talking to each other. Ashima was holding a dish in her hand, which she was eating, and was struggling with her hair as they were flying due to a fan.

'Let me help you,' Palash said, and he moved ahead. Aashima's heart started pounding with a feeling that he'll touch her while moving her hair behind her ears, but she was surprised. He moved ahead and changed the direction of the fan.

'I would have helped you with your hairs by moving them back, but there are so many people who are stalking us. I didn't want anybody to talk ill about you, either now or later,' Palash explained himself.

Yes! Ashima was touched and impressed with him completely now. She was unable to hide her happiness. She was feeling something. She was not sure what was it, but it was special. They both were looking at each other and were smiling and blushing.

'Suno! See Aashi and Palash, aren't they looking good together?' Palash's mother asked her husband..

'Indeed! They are looking lovely. Shall we talk to him about it? Shall I talk to her parents?' Mr. Khurana asked his wife.

'Let's talk to him first, if he agrees, then we'll talk to them,' she replied.

Throughout the wedding, Ashima and Palash were together. They were roaming, they were chatting, and they

even had their dinner together. They were out of topics, but still they were talking. And at points times they were quiet, still they were talking.

'PALASH! come! We are leaving. Bye, Aashi beta!' Mr. Khurana shouted from a distance of five hundred meters and waved his hand to Ashima, and she reciprocated.

'So, that is it. Time to take your leave. It was nice meeting you, Ashima. I didn't realise how the time passed in your company.' Palash said these words by looking directly into her eyes.

'Same here, and you can call me Aashi,!' She tried to be little more friendly.

'Do you have an e-mail ID or a cell phone number?' Palash asked her, and she gave him her e-mail address.

They shook their hands to bid goodbye, which none of them were interested in doing. It was there in their eyes; they just didn't want to leave each other, they wanted to sit and talk, they wanted to be together—but Palash left the venue with his parents.

'Did you like her?' Palash's mother asked him as when they were driving back to their home.

'Mom! Relax!' he blushed in front of his mother and asked her to be calm and chill, there was no hurry. He asked them to let him know Ashima well, and if things worked out, only then would they move further.

Ashima kept on thinking about Palash the entire night. There was only one thing that was going into her mind again and again: 'Something was there!' She was smiling thinking about him and the way he complimented her. He was all over her head now. She was thinking about each and every thing that happened at the function when both of

them were together. She was completely lost in his thoughts that when she fell asleep.

'Aashi beta, Ayushmaan has mailed you few pictures, and he is saying hi to you,' Ashima's mother shouted, who was talking to her son downstairs.

Ashima awoke but was lying on the bed, still thinking about Palash and the moments they spent together at the function.

'Wake up now! It's already 11:00 a.m., do you have plan to sleep the entire day? Wake up and open your computer. I want to see the pictures.' Ashima's dad entered into her room and asked her to do so.

'Yes, Pops! Give me ten more minutes, please!' she replied in a childish tone and rolled on her bed.

'Okay, but be quick, it's already too late.' He told her and left the room, and Ashima was back into her thoughts. Palash had occupied her entire mind and heart. She just wanted to stay into his thoughts.

She got up to check her e-mail that her brother sent. Her parents were very eager and keen to look at the pictures. She switched on her computer and logged in into her Yahoo! account. There were three unread messages. She opened the link to check the mails; the first two mails were from her brother, and the third mail was from Palash Khurana, with 'Thanks for the wonderful time!' as the subject.

The moment she read the sender's name, her heart started beating in at very fast speed. She had a smile on her face and was curious as to what the content of the mail was. She opened the mails that her brother had sent and downloaded the pictures that her parents wanted to see and called them. She wanted to get over with that first and then wanted to read the mail from Palash alone.

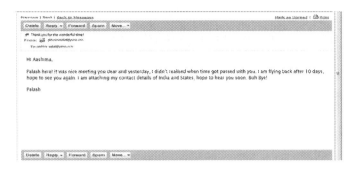

Aashima had a big smile on her face—and yes she was blushing. She wrote a reply to him.

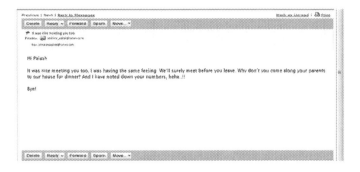

'Aashi, there is a call for you,' Ashima's mom shouted from downstairs.

'Coming in a bit, Mom!' she shouted back and came downstairs to attend to the call. 'Hello?' she said as she picked up the receiver.

'Hi Ashima! How are you?' It was a heavy male voice from the other end.

'Who's this?' she asked in a puzzled tone.

'How can you forget me yaar?' the person asked her.

'Oh! Palash?' she enquired.

'Hain? Who the hell is *Palash*?' the person asked her in a changed tone.

'Sid! You dog! Why were you talking in such a voice?' It was Siddhant who was calling her; she recognised him the moment he changed his tone.

'I was just trying to have some fun. Who is this Palash?' he asked her again.

'Tu pagal hai? What was funny in that?' she replied in an irritated tone.

'Sorry! Now don't be mad at me, I've a news to give. I bought a mobile phone.' He sounded excited and happy.

'Really! Oh wow! That is awesome, man, congratulations. When did you buy it?' She was not mad at him anymore and was happy for him.

'This afternoon. I asked Papa from where he had bought his phone, so he told me that he know this vendor at District Centre. This vendor has a tie-up kind of thing with Papa's office. Everybody buys landlines and mobiles for office and for personal use from this guy only. So I went to him in the afternoon, and he arranged a Nokia 1100 with Hutch connection for me, with some discount,' he told her very enthusiastically.

'That's great, yaar! You must be enjoying your new gadget now?' She sounded excited as well.

'Oh yeah! I was playing snakes the entire day. The game is awesome and addictive, and the moment my number got activated, I thought of calling everybody to give my new number. I called Krisha's landline, but no one picked, so you please give her my number,' Siddhant told her.

'Haan! Don't worry! Tell me the number' she asked him and wrote down his new cell phone number.

'I think you and Krisha should also get a mobile, then we can talk whenever and wherever we want to, eliminating the flaws of landline phones,' Siddhant told her.

'Yeah! That's a really good idea, I'll talk to Papa about this, but if he'll say yes, you have to get me the same discount that you have got on your phone!' she asked.

'Don't you worry about it,. Now tell me, who is this *Palash*?' Siddhant asked her again about this unfamiliar name.

'No one!' Ashima replied, see I have to go so i will catch with you in sometime.

After talking to Siddhant, Aashima went back to her room and sat in front of her computer and started completing her article, which she left to attend to the call.

She was unable to start her work as she was preoccupied with her thoughts. She was questioning herself what if Siddhant was right? Had she really fallen in love with Palash or was it just as infatuation? 'I felt some spark after meeting him, but is he the right person? But we don't know each other, we have met only once. Shall I listen to Sid or not?'

She realised she was talking to herself from past half an hour and have not came to a conclusion yet and decided to drop whatever she was thinking and went back to her incomplete article, which has to be published in the next edition of *India Today*.

Chapter 13

Mobile Phone it is

Meanwhile, Karishma was finally done with her post-graduate studies and now she was going to enter the world of bankers, which she was always fascinated about. She was through with her interview in ICICI Bank, for the post of assistant manager in corporate finance, with a starting salary of Rs.30,000. She was very happy and overwhelmed. Her family members were feeling proud as well.

She went to Ashima and gave her this news. Ashima hugged her out of her happiness and congratulated her.

'I am so, so, so, so, so, so! Happy for you, Krisha. Finally, you made it, and now you can do whatever you've dreamt of,' Ashima said in a very excited and happy tone.

'Yeah! I was very tense before the interview, but I managed to answer the interviewer, and yes, they hired me,' Karishma replied in the same excited and happy tone.

'Achcha, listen, Aashi, please talk to Sid and ask him from where he had bought his mobile phone. I want to buy one for me now. I don't want to go at work like a student or a dumb girl from any dumb college. I'll go there as a

professional, and for that I need new clothes and a mobile phone. Clothes, I can buy with you, but as you told me, Sid's dad have some *jugaadh*, then why not use that *jugaadh*?' she continued talking while giggling, and she winked at Aashima, who was not feeling good at the way Karishma was behaving. She was sounding weird; there was a change in her tone and attitude, which did not seem to be positive in Aashima's eyes.

'Okay! I'll talk to him. Even I am planning to buy a Nokia 1100 for myself also. I'll ask Sid to talk to his dad and tell us when we can go to buy it,' Ashima replied.

'What? Nokia 1100? No, Aashi! Why are you buying that monotonous phone? I was thinking that we'll both buy a same phone, Nokia 6600,' Karishma said in a tone as if she was crying.

'Are you crazy? I am not going to put 12 to 15000 on a gadget when I am getting the same calling features of Nokia 1100. And how the hell are you planning to buy that phone? You haven't started working yet.' There was an anger in Ashima's voice.

'I'll ask Papa to lend me money, which I would return as soon as I receive my salary, and there are lot more things in that phone than your 1100. There is camera in it, you can send files from one phone to another, coloured screen, and lot other things.' Karishma started bragging about various functions of the mobile which she wanted to buy, in an irritated tone.

Ashima was irritated but she tried to ignore. Meanwhile, Siddhant talked to his father about the phone dealer after receiving a call from Ashima. His dad talked to the vendor and told him to go to the shop and buy whatever mobile you guys wanted to buy; they have talked about the discount.

All three of them met at District Centre exactly at the time which they had decided. They were happy to see each other as they were meeting after a long time. Ashima and Karishma both were very excited for their new phones. Karishma was nagging both of them again and again to walk fast. Her happiness and excitement could be heard from her voice and could be seen on her face.

They went into the shop. Siddhant gave his father's reference to the shopkeeper. Ashima and Karishma both decided to buy same mobile phones and asked for their models, Nokia 1100. Both of them got very excited and happy when the shopkeeper handed over them their phone boxes. Both of them learned the features and specifications and came out of the shop after buying their phones and decided to sit in McDonald's for a while. They had a burger and some drinks over there with loads of talks and left for their houses.

Karishma texted both Ashima and Siddhant the moment her number got activated and showed how excited she was about her new phone.

All three of them were lost in SMSs and chatting. They kept on talking to each other, either by calling or by messaging one another. They were so much involved in

exchanging messages to one another that all of them forgot about everything: Ashima forgot everything about Palash, Karishma forgot about her breakup and her new job, which she yet had to join, and Siddhant forgot how Karishma had behaved with Ashima and him. All three were very happy.

The mobile phone, where it turned out to be a boon for Aashima and Siddhant, as it was helping them a lot in their careers, it turned out to be an addiction for Karishma. She was sleeping with her phone, waking up with it, using it in the washroom and every other place where she could use it.

Krisha · Hutch

My wife is a sex object.

Every time I ask for sex...
she objects

Options

Krisha · Hutch

Hahaha!! So funny na Aashi?

Options

Karishma started sending adult jokes and messages, which her other friends use to forward her, to Ashima. Ashima never liked those message, and she tried to explain this to Karishma so many times, but she never understood. On the contrary, she tried convincing Ashima that she should enjoy such jokes and messages and she should grow up.

'So, today is your first day at office, beta, all the very best to you. We all are very proud of you.' Karishma's dad gave blessings to her while they were having breakfast, together on the dining table.

'Yes, beta! We are really proud of you. Do well in your career.'

Mr. Seth put a hand on his daughter's shoulder and gave a slight hug.

Karishma felt blood running fast in her body, and she got ready enthusiastically after listening that her family members were proud of her. She got motivated and wanted to prove that their daughter will always do the best thing to make keep them saying that they were proud of her.

She reached her office on time and with full of energy. After doing all the documentations and paperwork, she got her desk with her name printed on a paper and pasted on the computer's monitor.

Karishma was asked to handle 'publishing house' industry in which she had to deal with the clients in the office and was also supposed to do visits to their sites as well. As it was her first day at the office, there was less work, and she had got the whole time for texting and texted Ashima.

Krisha Hutch

Getting bored, no work today. 2 hot guys in my team.

Options

Aashima texted her back; she was busy with her office work. Krisha still messaged her again telling about things she got.

Krisha Hutch

Just got my nameplate and visiting cards. I am planning to decorate my desk.

Options

Aashi Hutch

You can put photos of all 3 of us.

Options

Krisha Hutch

Yaa!! I can do that. Listen I'll nudge you in a while, they have given me some forms to fill. Bye Bye!

Options

Karishma was now busy in her job life, the corporate banking life, which she always wanted to do, though she was not completely happy. But no one is really happy with their job if you'll ask them.

One morning of this monotonous life, her boss called her to his office to introduce to her their client.

'Karishma! This is Mr. Malhotra, he owns his publishing house in Pratap Nagar. Please tell him about our loan schemes and our new products.' Her boss told her with a fake smile on his face and continued, 'Mr. Malhotra you can go with her. She is our assistant manager. She is dealing in the publishing houses.' And he guided both of them out of his cabin.

Mr. Malhotra was a twenty-four- or twenty-five-year-old guy, with fair complexion. You can't call him ugly or handsome; he was somewhere in the middle—a decent-looking guy. When he sat in front of Karishma, she realised that his face was little familiar; she might have seen him somewhere. She was trying hard to recognise his face, but nothing was coming out.

'Karishma Seth! It's so good to see you. What happened? You haven't recognised me yet?' Mr. Malhotra asked her in a very casual tone.

'No, sir, I am afraid I haven't recognised you, though your face is very familiar,' she replied with a puzzled look but with a smile on her face.

'I am Rajat, I was in your class during our graduation, roll number 32. Still lost or you want me to tell you that I was the one who gave all of my notes to you and you returned them back just before the exams, ha ha ha!' And he laughed after completing.

'Oh my god! *Rajat*? No! No! I've not forgotten you, it's just I am looking at you after such a long time. You changed a bit. Don't take me wrong—change in a good way,' she replied with a smile and continued, 'So how have you been? It has been a long time. We all have changed and that is why I was unable to recognise you, though you were looking familiar, he he he.'

'It's fine, you don't have to say sorry again and again. I know it happens.' Again, he replied in his casual tone.

They started talking to each other about their life after graduation. Rajat told Karishma that he was helping his father in their publishing house, and now he was planning to expand it that was why he was there in the bank. He told her about his work and what he was planning for. After some casual and official talks, he asked Karishma out for a coffee after office, and she accepted and asked him to pick her up at six in the evening.

Rajat came to pick Karishma up from her office in his white-coloured dented Maruti Zen. Karishma was stunned to see that a guy who was bragging about his business, his living standards, and other things, was riding a fully dented car. Why call it a car? It was scrap moving on wheels. He took her to a coffee shop in Naraina Market, and they talked a lot while sipping their coffees, and after that, he dropped her at Peera Garhi Chowk, and they exchanged phone numbers.

After dinner, Karishma went to her room and picked up her mobile, which was charging, to call Ashima. She saw a notification: '1 New Message.' It was Rajat who texted her.

```
Krisha                          Hutch

Hi! Nothing just got done
with dinner. You tell what's
up with you?

            Options
```

```
Rajat                           Hutch

Nothing!

Just lost in your thoughts.
It was nice spending time
with you
            Options
```

Yes, Rajat started flirting a little bit, and Karishma didn't mind that. On the contrary, she liked it, and she started replying in the same way.

```
Krisha                          Hutch

Hahaha! I hope your thoughts
are not NAUGHTY! Hahaha!

            Options
```

They had a great chat the whole night, and they said goodbye at 3:00 a.m. when Karishma realised she has a busy day ahead in the office

The next morning, she texted Aashima from the office.

Krisha Hutch

What's up girl? Sorry couldn't talk yesterday, was talking to a guy from graduation. He is our client.

Options

The moment Ashima read her this message, she went to her memories of how Karishma had made mistakes in her past when it came to a guy. She was worried for her. She didn't want her to repeat her mistakes. She didn't reply to her as she wanted to show that she was not happy.

Krisha Hutch

Are you there? Hello?

Options

She texted her again.

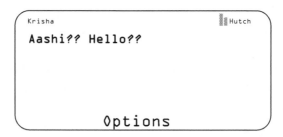

Krisha Hutch

Aashi?? Hello??

Options

Karishma was texting Ashima continuously, again and again, but Ashima was not in a mood to reply.

Krisha Hutch

Don't be upset yaar! He is just a friend, nothing more than that. Please Chill.

Options

Ashima got irritated by the constant SMSs by Karishma and texted her back that she was very busy in the office and she can't talk.

Both, Ashima and Karishma didn't talk to each other for many days as Ashima had to work upon various articles, and she didn't wanted to do that in an irritated mode. Whereas Karishma was not busy in her work, but with Rajat. She was talking to him day and night—on calls, on SMSs, and meetings. Both Rajat and Karishma have developed interest in each other; they adored each other's company. Rajat has a habit of bragging about the brands he wore and has. His Tissot watch was worth Rs. 150000, his Nike shoes were worth Rs. 10000, his RayBan glasses were worth Rs.4000, his Tommy jeans were worth Rs. 4500, and other things. He told all this to Karishma, and she has started getting impressed by his style and fashion sense. She started noticing his brands, and yes, she was tempted to be a brand girl now.

Chapter 14

She said 'Yes'

One morning, Ashima was getting ready in her room and was about to leave for her office when she heard their doorbell ringing and heard her parents laughing and greeting somebody. She went downstairs out of curiosity to finding out who was there on the door. See saw her parents sitting with Palash's mom and dad in the living room.

'Oh! Namaste, Uncle! Namaste, Aunty! How are you? It's good to see you both,' Ashima greeted them.

'Namaste, beta! We are good. How are you? Where are you going so early on Sunday morning?' Mr. Khurana, Palash's dad, asked her.

'Media persons have no Sundays and no holidays, Uncle They are supposed to work 24/7, 365. There is some report to be edited that have to be aired on Tuesday, which is why they have called me today, though they would give me a comp off later,' Ashima told them.

'Where are you working, beta? Palash told us but we forgot,' Mr. Khurana added.

'I am an editor in Aaj Tak channel and also doing freelancing for *India Today* magazine,' she replied with her eyes on the clock as she have to leave soon.

'Palash and you have become good friends. Whenever he calls us, he talks about you. He even told us that you both exchange mails over this—what you call it, yeah—Internet,' Palash's mother jumped into the conversation.

Ashima didn't say anything but replied with a confused smile.

'So, beta, what are your plans for the future?' Palash's mom asked Ashima.

Ashima was stunned by her this question; she started talking to herself inside, 'My future plans? Why the hell is she asking me this question? I just told her that I am working at a very good post in a very good organisation, what else I have to plan for my future?' She was confused and surprised to see Palash's parents asking so many questions from her.

Suddenly she heard her mobile's ringtone from the other room where it was getting charged. She went to pick it up, it was from her office. She attended to the call and hanged up after five to seven minutes.

When she was returning to the living room, she heard Palash's parents talking to her parents about her only. They were praising her. She heard Palash's mother saying, 'She is a very nice girl. If you like Palash, then we can go ahead and make both of them talk to each other.'

'What? Really? Are they talking about my marriage? No way, I want to do love marriage, not arranged. Palash? I don't even know him properly, how can I marry him like this? Isn't too early?' Ashima started mumbling to herself. There was a tsunami of questions coming in her head the

moment she heard them talking about her marriage. She was confused and totally puzzled.

She took a deep breath and gathered courage to go out into the living room and face everybody.

'Pops, I am getting late for work. Can I leave?' Ashima asked her father. Her voice was bold, but she was freezing at that moment, freezing out of nervousness.

'Yes, beta, but listen, try to come early today,' her father said.

Early? Why? I am not getting a good vibe. Papa has never asked me to come early like this. Why does he want me to be early? Ashima thought.

'Yes, Papa, I'll try. Okay, Uncle, Aunty, I'll leave now. It was nice to see you, I'll see you soon.' Ashima bid them goodbye and got out of the house, and the very first thing she did after coming out was took a deep, long breath of sigh. She felt relieved to escape those questions and talks. The entire way to her office, she was occupied with these thoughts only.

She had a coffee after reaching the office and was trying to divert her mind when her boss called her in his cabin.

'Hey, Ashima! Good morning! On time on Sunday morning.' Her boss greeted her the moment she entered his cabin.

'Okay, listen, I've read your articles. You are doing pretty well. You are doing great. We even got a very positive and appreciative feedback from the top managements about it as well, and all this credit goes to you.' Her boss told her with pride on his face and voice. Ashima felt great; her work has been recognised and getting appreciated by people.

'I've called you to give your next assignment, a new article,' her boss added.

'Yes, tell me, sir, what is it?' she asked him enthusiastically.

'You are supposed to write an article on the topic, 'Love, Marriage, and Arranged Marriage,' he replied.

'*WHAT? Now that was the last thing I expected today. Is this destiny?*' she murmured in her mind. 'Right, sir, I'll start working on it,' she replied in a very weird tone.

'Is something wrong, Ashima?' he asked her.

'No, no, sir, I am absolutely fine. I'll take leave then and get to work,' she said a thank-you and exited his room back to her desk.

On her desk, she had a mini clipboard where she had pinned few pictures from her childhood. She started gazing at those pictures with thoughts in her mind of how the time has flown; few years back, there were no worries, and she was leading a carefree life, and now it's a time when her parents are talking about her marriage. *Am I that old to get married?*

She was lost in her thoughts, when suddenly she felt her mobile vibrate. She picked her phone up to check; it was a message from Karishma.

```
Krisha                        Hutch

Oye there yaar? I want to
talk about Rajat. Can you
please talk?

            Options
```

Ashima was already pre-occupied so much with her thoughts, and in addition, she had to complete her work as well, so she quickly replied.

```
Aashi                          Hutch

Little Busy! Anything
urgent, I am in the office.

              Options
```

Karishma immediately messaged her back.

```
Krisha                         Hutch

Yaar he criticises me a lot
that I don't wear branded
clothes and shoes. I am
really upset.

              Options
```

Ashima was pissed by her as she was messaging her constantly and asking about that guy.

```
Krisha                         Hutch

Aashi I didn't replied him
today and when he called me,
my phone was busy. What
should I say to him?

              Options
```

Krisha Hutch

Aashi can I say that I was talking to you?

Options

Krisha Hutch

Oh no! He'll say that you can talk to her and can't even text me back.

Options

Krisha Hutch

Aashi can I say that I was talking to mom? I'll say it was something urgent and important.

Concentrate on your work
Options

That was it for Ashima; she got irritated to her core with Karishma. She was wondering why Karishma has to give so many excuses to *just a friend*? Why did she even have to explain herself? She wanted to tell all these things to Karishma but dropped her idea as she knew chewing pebbles would be easier than making Karishma understand something. She switched her mobile phone off and started working on her article: 'Love, Marriage, and Arranged Marriage'.

Ashima was still wondering why this thing was happening in her life. Only this morning she heard something which she had never thought, and now this article. She heaved a sigh and started working on her article.

> *Marriage*—the word itself carries a lot of weight. When a person decides to go for it, that person actually thinks a lot, but the question is what is he/she actually thinking? Anyways, there will come a time in people's married life when they start thinking about why did they get married; their lives were pretty much easier otherwise.
>
> Marriage is like a magnet. It will attract a person towards it, and then after some years, it will lose its power of magnetism, and *boom!* People start realising what a life they had when they were bachelors.
>
> Is this really true? To know more, our team took a survey from people who are married and people who are dating, according to that figure . . .

Finally, she was done with her article. She took the printout and handed it over to her boss, who was sitting in his cabin, to have a look at it. While moving back to her desk from her boss's cabin, she was thinking that what she wrote in her article. She thought, *Arranged marriage is not my cup of tea*. But then she thought about Palash; she realised that he was probably the first guy with whom she had felt connected to, and she found him cute as well.

Ashima was in a huge dilemma, a dilemma between her heart and brain. On one side, she was thinking from her heart: Palash was the first person in her life with whom felt rooted; she liked each and every thing about him. It was there in her heart that she wanted to marry a guy like him only. But on the other hand, it was her brain that was telling her that she was not made for arranged marriage and she was not prepared to marry at her current age. She was totally confused about what she should do: should she listen to her heart or go with her brain?

Lost in her thoughts, she reached her home and realised there was nobody at there. She had a sigh of relief that she didn't have to face anybody, and nobody would talk to her about the things they were discussing with the Khurana family in the morning. She changed her clothes, lay down on the bed, and tried to read a book to relax and divert her mind, but her attempts were failing as her brain was still occupied with the things happened that day.

While she was busy in her thoughts, she heard the doorbell of her house and realised her parents were back. She heard her father asking about her arrival from the maid, and she told him that Ashima was in her room. Ashima could hear the sound footsteps of her father who was coming upstairs to her room. She was feeling trapped, like a mouse in a cage, nowhere to go.

'How was your day?' her father asked upon opening the door of her room.

'It was just fine, little hectic. Tell me why did you ask me to come early? Is there anything to talk about?' she enquired him with sinking heart.

'My little doll knows her papa so well. Yes I want to talk to you about something. You met Palash and his parents.'

He was trying to speak something but got interrupted by Ashima in between.

'Pops, I know what you want to talk about. I heard what you were talking about with Palash's parents in the morning, but to be very frank, I am not ready for it right now. I think it's pretty early right now, don't you think?' she asked her father.

'See, he is a very nice guy, and his parents were telling us that he liked your company and your nature from the very first meeting. It's never too early or late. When you find a nice decent guy, that is the apt time to get married. You are acting very childish. At least talk to him once.' Her father tried to explain his point to her.

Ashima knew that talking to her father on this topic would be useless as he'll counterattack her till she agrees to talk to Palash.

'Okay, I'll talk to him when he'll be in India. When is he coming?' she asked her father.

'Beta, talk to him on the phone, he is not coming any sooner, now he'll come when you two will be getting engaged,' he replied.

Now did I hear him correctly? My engagement to Palash?' Ashima wondered. She hadn't even talk to the guy, and her father had already planned their engagement.

'Papa, let me just talk to him once. Stop making dream castles.' Ashima sounded irritated.

'He'll be calling you by 7:30 or 8:00 p.m., I've asked his parents to call you by that time as you'll be free,' he replied with a big smile on his face.

'Wow, great. That was why you wanted me to be home early. Fine, I'll talk to him only for you, Pops.' She was still sounding irritated.

'Good, I'll talk to you after you talk to him. I am sure you'll like him,' he said and left the room, leaving behind his daughter sitting, wondering what would happen next. She again got occupied with Palash's thoughts now. She was questioning herself what if she'll like him and what if she'll not like him?

Baffled by her thoughts, she didn't realise when she fell asleep. She woke up with her phone's ringtone. She picked up her phone to check who was calling, but it was an unsaved and unfamiliar phone number, starting with '+408'. She started thinking who it might be when suddenly her eyes went to her room's wall clock which was showing the time '7:45'.

Palash. She said his name in her mind; it was him calling.

'Hi, Ashima, how are you?' Palash asked her; he was sounding excited to talk her after such a long time.

'I am good, how are you?' zhe replied in a very dull manner. She was feeling bit awkward talking to him when she knew the purpose of that call. Palash could sense that she was not feeling comfortable and bit awkward too.

'Ashima, I know we met just the other day, and I felt some connection between you and me. I don't know if it was same for you or not, but I felt rooted to you in some way. Yes, I was mesmerised with your smartness and sharpness, and you are equally beautiful as you are smart. I really wanted us to be a very close friends and then would come to a decision of whether we are made for each other or not, but our parents had others plans in their mind I guess. I always believed in love marriage, but ours would be arranged. But still I am feeling that it is the one that I wanted. I am just trying to tell you that what is going in my mind and heart.

Marriage is a very big term, and I'll not put any kind of pressure on you. It would be your decision,' he said as he opened his heart to Ashima.

Ashima was smiling and was impressed with him after listening to all this. She adored his simplicity, decency, and the courage of expressing his feelings without thinking about the result. That night, both of them talked to each other for hours. Both of them were enjoying each other's talks and again felt something spark between them, that there was something special between the two of them. This talking on phone continued for a few days; they even started doing video chats on Yahoo! Messenger, until one day, they both accepted that the special thing that they were feeling between them was *love.* Both sets of parents were happy and excited after hearing the positive response from their children, and they started planning out a Roka ceremony. They started looking for a venue, preparing guest list, catering, and all necessary things that were required.

Everything happened so quickly that Ashima realised that she hadn't told her best friends about the most important decision of her life. She was dead sure that both Karishma and Siddhant will be mad at her when they heard this news. She called them up and asked them to come over to her place as she wanted to discuss something very important and urgent.

Both, Karishma and Siddhant reached Ashima's house as quickly as they could, and Ashima asked them to come to her room.

'O Pagal! What was so urgent? I came without even taking a shower,' Siddhant tried to tease her.

'Please listen calmly, guys, don't get freaked out on this. I am getting engaged next month.' Ashima told both of them.

It was like a shock for both Karishma and Siddhant; they were not expecting something like that. Few days back, she didn't want to get married that early, and there was no guy whom she likes, so what had happened that she was getting engaged now?

'You are joking, right?' Karishma asked very seriously.

'See guys, everything happened so quickly that—' Ashima was completing but got interrupted by Karishma.

'That you couldn't consult us—forget consulting, you didn't even tell us that you liked a guy.' Karishma completed Ashima's line, she was angry.

'Krisha wait, who's the guy, Aashi?' Siddhant asked.

'You remember the guy whom I met at my cousin's marriage?' Aashima asked.

'Oh yes, I do remember him, so you were talking to him ever since?' Karishma interrupted her again.

'No, our parents asked us to talk to each other, and it just happened. I liked talking to him, so did he, and we clicked. We are way too comfortable talking to each other, like I am with you guys. He is very comforting, and this feeling between me and him is so special. It's the first time I've felt like this.' Ashima completed, opening her heart in front of her best friends.

'You are sounding like you are in love. I can see it in your eyes,' Siddhant said and smiled.

'Ya, Sid is absolutely right. See, Sid, she is blushing. Aww!' Karishma pointed out at her cheeks.

* * *

And finally it was Ashima's Roka day. Landmark Banquets at Peera Garhi Chowk was the venue for the function. Everybody was so excited and happy for the occasion. Palash and Ayushman came back to India together from USA.

Ashima was looking very pretty; she was wearing a red-coloured suit with a small crown over her head. Palash was wearing a black-coloured three-piece suit and was looking way too handsome; both were complementing each other. Siddhant and Karishma had prepared a dance number, which they dedicated to their friend. And at the end, Siddhant gave a performance with his band. He sang Ashima's favourite songs and few Punjabi peppy tracks to which each and every person in that banquet grooved. Ashima was very happy.

Chapter 15

The City Of Love: Paris

It was July, and Ayushman was done with his studies, and Aashima's entire family was very excited for his convocation, and they have planned to attend it.

Everything was packed as they had to leave early in the morning. Aashima called Siddhant as she wanted to know what time he was planning to leave for the airport.

Siddhant had taken admission at SAE Institute, Paris, in a diploma course for Sound Engineering, and his session was going to start in fall. He had planned to leave with Aashima and her family because he wanted to be the part of Ayushman's convocation ceremony. Both Siddhant and Ayushman had a great connection since their childhood. When Ayushman was in India, both of them used to hang around together in the evening, used to play together, and all those things that best friends do. When Ashima told Siddhant about Ayushman's convocation, he got excited and expressed his interest in attending it and agreed in going to the USA one month prior to the beginning of his course. And when Aashima told this news to her brother, he got

excited, and he invited Siddhant to a Euro trip which he had planned with his friends after the convocation, which Siddhant agreed to go as he could join his college after the trip only.

'All packed?' Aashima called and asked Siddhant.

'Yope! All set.' He sounded excited and happy. 'You tell? All set to meet jeeju? he continued.

'Shut up, hoja! yeah, I am excited. He told me that he has planned to take me to some romantic places as well.' She sounded very excited and happy.

'Oh! That's great,' Siddhant sounded enthusiastic as well, but one could sense some kind of sadness in his voice as well. He was thinking about Karishma; he was thinking that now he'll get far away from her.

'What happened? Why sounding sad? I know you are thinking about Krisha, but you'll be coming back here, right? You'll not be staying there forever, so don't be sad. Just keep this thing in mind that you are going there to lead a great future. You are going there to pursue your dream, and that is your music.' Aashima had understood Siddhant, so she tried to console him.

'Ya! Ya! Ab stop scolding me. Is Krisha coming to drop us?' Siddhant asked with an excitement and hope in his voice.

'No, I asked her but she had an important meeting to attend in the morning.' Yes, Aashima lied to him as Karishma was going to Shimla for a short trip with Rajat. Aashima called Karishma to ask if she was coming to drop Sid, as he will be coming home after a year. She requested her to manage Sid and to not tell him about the trip.

'Okay!' Sid was sounding little low after knowing this. 'Chall, let's go to sleep, I'll leave for airport by 9:00 a.m.

Will meet you at airport directly.' Siddhant said in a very low tone.

'Okay! Will meet you there then, and stop thinking about Krisha now, just think about those hot air hostesses of Cathay Pacific Airlines!' Aashima giggled and tried to cheer him up.

'Ya Ya! Sure, chall bye. Have to sit with parents for some time. Catch you tomorrow.' Siddhant bid goodbye to her and hang up the call.

The next day, Aashima and her family reached airport in a cab and saw Siddhant standing in front of gate number 3, terminal 2 with his parents and luggage on a trolley. Their parents greeted each other, and Siddhant touched his parents' feet to take leave. His mother was in tears; he gave her a big tight hug and asked her to calm down. He was trying hard not to show his tears to his parents and went inside with Aashima and her family.

All of them were sitting in the waiting area after they got done with their luggage check in and security check. Their flight was on time, but there was still some time left before boarding. Aashima brought coffee for her parents, and they were sipping it while having discussions about their relatives and other things. Siddhant was still thinking about his mother and Karishma. Aashima read his face and patted his shoulder.

'Leave everything. Aunty will be fine. You just cheer up.' She told him with a smile on her face.

'Yeah! Listen I am just going out for a bit.' He told Aashima, signaling her with his fingers that he was going to smoke. She didn't stop him; she knew he'll do everything that would help him in calming down and just nodded in a yes to him. She told her parents that he has gone to the washroom when they asked her that where has he gone.

Siddhant went to the Duty Free shop and bought a twenty-pack cigarette of Classic Mild from there and went inside the smoking lounge. He lit his cigarette and called his mother; he was worried for her. He told her to relax and tried to explain to her that he'll be back in ten months. When he got done with the call, he made another call to Karishma. It kept on ringing for two to three minutes, but she didn't pick. Siddhant felt bad; he was hurt. He was continuously questioning himself 'Is this friendship? Isn't she supposed to at least bid him a last goodbye? What has happened to her? She has totally changed.' He realized that it was his seventh stick, and Aashima's parents must be wondering where he has gone. He wrapped up his carton in his backpack and exited the smoking lounge.

Aashima was wandering around the Duty Free shops; she saw Siddhant coming out, and she called him by shouting his name.

'Yuck! Dude, did you take a bath in your cigarette's ash? How many have you puffed, dog? You are stinking very badly of cigarettes.' She told Siddhant the moment he reached her, with animated gestures on her face.

'Oh fuck! I thought it would not have been that much. What shall I do now? I didn't realize that I had so much of it while I was talking to Mom,' he replied.

'Just go to the washroom and do something—at least wash your hands and do gargle and please put on some perfume as well. The rest we'll make some excuse to my parents,' she told him in an authoritative way.

Siddhant went to the washroom, and when he came back, Aashima took him to have some coffee. By the time they reached where her parents were sitting, the smell of cigarettes from his clothes had been a bit neutralized, and

nobody noticed it that much. They got on board, and the flight took off on the destined time.

'Welcome to United States of America. We have landed at John F. Kennedy International Airport. We hope you enjoyed flying with us and you'll give us another chance to serve you again. Thank you for flying with Cathay Pacific. Have a pleasant stay,' the flight attendant announced.

Yes, United States of America it was. They all landed and came out to the arrival gates after collecting their luggage from the conveyer belts.

'Aashi, Aashi, over here!' Somebody was shouting Aashima's name from the other corner. It was Ayushman who was calling her name and was waving at them. Ayushman was not alone; Palash was also there. It was a surprise for Aashima as she didn't know that he was also coming with Ayushman to pick them up.

Both Palash and Aashima were happy to see each other after so many months. Both of them were blushing; their cheeks turning red, and one could see love for each other in their eyes. Palash moved ahead and gave her a tight hug.

Palash moved ahead to meet Aashima's parents. He greeted them by touching their feet, shook hands with Siddhant, and asked them about their journey.

Aashima was equally excited and happy to see her brother as well; she hugged Ayushman and gave a little punch in his stomach out of love and congratulated him.

'Oye, rock star! Finally, you are here!' Ayushman just shouted out of excitement on seeing Siddhant, with his arms wide open for a hug. Siddhant moved ahead to hug him, and they started patting each other's back. Everybody was so happy.

Palash guided everybody to his car—Honda CRV; they adjusted their luggage and got seated. Palash had arranged a fully furnished apartment in Brooklyn from his company.

It was a beautiful three-bedroom apartment, with all sorts of luxuries that are required in the house, with a great view of the city from the window.

'Papa, you please take some rest. You and Mom must be very tired and jet lagged. I think you and mom should take a nap. We'll to the city tomorrow,' Palash told Aashima's father, to which he agreed and went to a room to sleep along with her mother.

The young brigade was sitting in the dining area, with beer bottles on the table. All of them were planning on what they want to see and where they wanted to visit the next day.

'Palash, you'll be taking me to the Times Square, right?' Aashima asked Palash, acting like a child.

'Yes of course, we'll go to Times Square tomorrow,' Palash replied in the same manner, making fun of her.

'We'll be visiting Brooklyn Bridge, Coney Island, and in the evening we can give a visit to Wall Street and Times Square.' Ayushman jumped in between them while sipping his beer.

'That sounds perfect,' Aashima replies.

'Yes, and we'll go on Liberty tour the next day, and after that we've planned a visit to Niagara Falls. You'll surely love that place,' Palash told Aashima.

'Sounds fun, I hope you have included Madison Square Garden in your list as well?' Siddhant asked Palash with a cigarette in his mouth; he was going out to the balcony for a smoke.

'Why on earth you want to light that thing right now? Can't you just sit and talk? You are seriously smoking a lot, Siddhant,' Aashima yelled at him.

Siddhant knew that this time she was totally pissed; whenever she called him by his name, it's clear that she was mad at him. Siddhant immediately took that cigarette out of his mouth and got seated where he was standing.

'Don't be like this Aashi! Let him do whatever he wants to. Go ahead, Sid. Darne ka nahi, bindas jaa.' Palash asked Siddhant to go and do whatever he wants to do.

'I love you, man. You are the best, jeeju!' Siddhant blew a flying kiss at him and went out.

'This is not right, Palash. You can't allow him like this. He is ruining himself, and you are encouraging him, this is very wrong.' Aashima was very mad at him.

'Relax,' Palash tried to continue but got interrupted by her again.

'Please don't give me any excuse. Just leave me alone for a while. Go, you also, go outside.' She pointed her finger at the door of the balcony and asked him to leave.

'Are you out of your mind? Why are you behaving like this?' Ayushman asked her in a confused manner while still sipping his beer.

'You! You also get out.' She snatched his bottle and directed him to the same gate.

Siddhant was busy making his smoke rings and was humming songs when the balcony's door opens up and two sad faces joined him.

'What happened, guys? Why are you looking sad?' he asked Palash and Ayushman in a funny accent with cigarette in his mouth.

'Saale! Teri cigarette ki wajah se, we got a scolding,' Palash said with a smirk on his face.

'Yes, but why did she ask me to get out? And if she wanted me to be out, why not with the beer bottle?' Ayushman asked while scratching his head, and they started giggling.

'Sir ji! She is going to be your wife, be prepared for such things. We all have faced such things a lot.' Siddhant told Palash and was still giggling.

'Achaaa! Sahi hai! Sahi hai!' Palash replied back.

'Are we going to stay here all night? I want to pee,' Ayushman asked in a very worried tone.

'Follow me. Let me sing her favorite song. She melts every time she hears it!' Siddhant winked at both of them and asked them to come inside.

They get back into the room slowly. Aashima was looking very angry while she was reading a book. Siddhant asked Palash and Ayushman to hold their ears.

'Ye kya bakwasbaji hai? This is sheer nonsense,' Palash asked with a smile.

'Sir Ji! Trust me, I am giving you all the tips for handling your lady after marriage. Try saying sorry in different and creative ways, she'll definitely melt.' Siddhant winked back at him again and started singing, 'Tere jaisa yaar kahan, Kahan aisa yaarana, Yaad karegi duniya, tera mera afsana . . .' And he continued.

Aashima saw the three of them holding their ears, as if some teacher has given them some kind of punishment. The moment she saw them like this, she was forced to laugh and change her expression. All of them noticed and they all started singing and slowly moved towards her, and soon all four of them were laughing loudly and rolling on the floor.

* * *

After roaming and exploring different parts of New York and other points of America for four days, finally the day has arrived for which everybody was there: Ayushman's convocation ceremony—a proud day for all of them. Everybody had brought some gift for him, and Palash arranged a cake that had a figure of a guy in his graduation cloak and GRADUATE written on it. Each one of them was very happy, you could see that on their faces. They clicked pictures with Ayushman, who was wearing his graduation cloak and hat, some were funny, and some were very sober. It was a very proud moment for Ayushman's parents when they saw their son walking to his graduation.

'Let's go out somewhere in the evening,' Ayushman asked everybody on their way back to the apartment.

'I can't go anywhere now. I am very much tired. I really need a cup of chai, and then I would really want to sleep,' His mother replied in a very loud and tired tone.

'Yeah! Even I don't want to go. I am very tired of so much travelling and roaming. I want to lie down on the bed and have to get lost in my dreams for hours,' Aashima replied in a very sleepy tone.

'Let these boys go if they want to, we'll be staying at home,' his father added.

So it was decided that the boys were going out for a boy's night out, with booze, booze, and only booze. They got ready for a drunken night in the streets of New York and were out by 6:00 p.m.

'So where are we going?' Siddhant asked curiously from the back.

'Let's go to Beer Garden. We can drink loads of beers there and the ambience of the place is also very good. They have big plasma televisions installed with various games playing on them, totally Shandaar jagah.' Palash gave his idea and sounded very excited.

'Let me be your guide for tonight,' Ayushman replied after listening to Palash's idea.

'So where are we going?' Siddhant asked again in the same tone.

'Just wait and watch, my friend,' Ayushman replied with a smirk on his face and hit the accelerator.

After driving for about thirty-five minutes, finally they were there at their destination; K Lounge it was. Palash's jaw was dropped; he was not expecting a place like that.

'Are we going there?' Palash asked Ayushman in a stunned tone.

'Oh ya!' Ayushman replied with an evil smile on his face and winked at him.

'No, we are not,' Palash said.

'Umm! Guys, can you please tell me what the matter is?' Siddhant enquired

'Tu rukk, and jeeju come on, don't be a kid. This is the most amazing place in the entire Manhattan. Now get into the mood and let's hit the bar,' Ayushman replied and patted Siddhant's shoulder to move.

'Why don't you want to go here, Sir Ji? Ayush is so excited for this place,' Siddhant asked Palash.

'Just wait and watch,' Palash replied, and they all went inside K Lounge.

Kama Sutra Lounge, the full form for K Lounge, was an Indian-themed lounge, with plasmas inside playing Mira Nair's Kama Sutra. The dim lights and the aroma

of jasmine flowers coming from the scented candles were giving a sensual and sexual touch to the ambience. The waitresses were wearing revealing saris and were talking very seductively. Everything was so arousing about that place.

'Is it a strip club?' Siddhant asked with his eyes wide opened.

'Shut up, dude! Don't insult the place. We call it "the sensual Paradise",' Ayushman replied while sitting on a couch.

'Your sister will kill me if she would come to know that I visited this kind of place,' Palash said while settling down.

'Come on, jeeju, you are talking like a teenager who has never visited such kind of places. Just relax and enjoy the night. Chill! EXCUSE ME!' Ayushman raised his hand to call a waitress, and within a minute there was six-foot-[tall blonde angel, wrapped in a bloodred sari with a deep neckline, revealing her cleavage. There was a naughty smirk on the faces of all the three boys.

'What is the best drink you've got, dear?' Ayushman asked her in a very casual and low tone.

'We have a great variety of aphrodisiac cocktails. You can choose any one of them, but if you ask me, I would say Jaipur Moon,' she whispered in his ear in a very seductive tone, which gave Ayushman goosebumps, and he started giggling.

'No beers? No whiskey? No liquor? No sharab?' Siddhant asked, still sounding confused.

'Chill, dude, they don't serve it here, but we can go down to their restaurant to have couple of drinks and can come back again. Don't you worry and just enjoy this erotic environment.' Ayushman winked at him and raised a glass of water.

They ordered three Jaipur Moons for them with their special *tantric tikkas*, with couple of more non-veg starters. The boys were having blissful time. They were enjoying their food and the drinks. Siddhant went for a smoke in the smoking section; there he foundd a girl wearing some kind of sari, and she lit his cigarette and gave a very naughty smile; he was mesmerized with the place.

The boys went downstairs in the restaurant for some hard liquor. Siddhant ordered whiskey, Ayushman ordered pints of Corona, and Palash just had a 60ml Jack and Coke. Palash didn't drink much as he was driving all them back.

After couple of drinks, they were back in the lounge. The DJ was playing all the hit Bollywood numbers, and yes, the boys went crazy, and started dancing like they were dancing in some Indian wedding. That was a sight to see.

They came back home late, Aashima opened the door and helped them in settling down. She asked them to sleep quickly, reminding them that both Siddhant and Ayushman have their Euro trip tomorrow and Palash has planned to take her to Boston, Washington, and Florida, along with her parents. All bid goodnight to one another and went to their respective rooms.

The next morning, Ayushman's three friends came to pick up both Ayushman and Siddhant; they have planned a trip to Paris. Both of them said goodbye to everybody, and within few minutes, they reached the airport to catch their flight to Paris. Meanwhile, Aashima and her parents were ready to leave the apartment with Palash.

All the boys took metro from airport and reached their hotel to change and get freshen up. Their Hotel was Holiday Inn in Montmartre. It was an Italian-themed hotel wich had

some amazing views of the city and was very well connected from the metro.

After checking into the hotel, they went straight to their room, settled their luggage, and sat in one room. Siddhant was trying to gel up with the other boys, and he was enjoying their company.

They opened the crate of beers that they had brought, and each one them were holding their pints of Corona. Siddhant took out his packet of cigarette and was about to light his stick, suddenly Ayushman stopped him.

'Dude, what are you doing? You can't smoke,' Ayushman said.

'What? You are not supposed to smoke in these luxurious rooms?' Siddhant asked out of fear.

'Why waste your cigarette when you've got this,' Ayushman said while taking out a hookah out of his backpack.

'Holy crap! Hookah?' Siddhant was surprised.

'Not just one, I've brought two of them with variety flavours and lots of coal, my dear friend,' Ayushman replied.

Soon, the boys from NYU were in their true colors; some were having hookah and and beer was flowing like water. They were totally stoned, singing Bollywood tracks—they were dancing, they were shouting, and doing all nonsense things.

After getting a little sober, they all decided to get out of their rooms and explore Paris. So they left their hotel at midnight and started walking out on the streets of Paris.

Paris, one of the most populous city in France. The city of Love as everybody calls it.

Ayushman asked everybody to move to Wanderlust club; he had heard a lot of it, and he really wanted to visit that place, so they all started looking for it.

It was a terrace bar and club and it had cool cafe's and shops on the lower level. It had open air dance music. Parties there used to start at 11 at night and continue till 6 in the morning. It had a beautiful view overlooking Seine river.

They reached there just at the time of sunset which was breathtaking from there. They were having excellent fashion themed night that day which included cat walks by French models.

'Now That's called timings' Ayushmann boasted as he was the one who chose this place.

'Drinks, anybody?' Siddhant asked the boys who were already staring the models.

'Ya, let's go and hit the bar,' one of the guys replied, and they all headed to the bar.

They were drinking like fish. Beers, vodka, whiskey, gin—they were having them all and without any break. They were dancing like maniacs, as if there'll be no tomorrow. All of them were shouting and jumping; they were enjoying totally. Siddhant asked Ayushman that he wanted to smoke and both of them went on a corner to smoke.

'*Fuck*, man! This is life,' Siddhant said while taking a cigarette in his mouth out of his packet.

'Seriously, man, this is so fucking bizarre,' Ayushman added and asked for a drag.

Both of them were happy high; they were sharing a cigarette and were praising the nightlife of Vegas, and suddenly they were interrupted by a voice from behind.

'Hi! Do you have an extra cigarette?' There was a French pretty girl wearing a red-colored top with a black thin jacket and blue denim shorts.

Siddhant and Ayushman turned back to her, and she was staring at Siddhant. Both of them were dumbstruck for

a moment after seeing such a pretty lady. Before Siddhant could say anything, Ayushman jumped in.

'Hi, yes, my friend over here have got what you are asking for, I mean he got cigarette,' Ayushman replied her with giggles and signaled Siddhant to give her stick.

'Thanks, it's such a relief. I was craving for it so badly. Hi, I am Emma,' the girl introduced herself.

'Hi, I am Ayushman and this dear friend over here is Siddhant, you can call him Sid.' Ayushman introduced both of them.

'Sid, nice name, but why is your friend not uttering a word.' Emma started giggling while puffing her cigarette.

'I guess he is out of words after seeing a pretty girl like you.' Ayushman tried to cover up for Siddhant.

'Stupid tu baat kyun ni kar raha hai?' Ayushman asked Siddhant without giving any hint to the girl that what he was saying.

'Oh! Sorry, I was dumbstruck by your beauty, I guess, ha ha ha.' Finally, Siddhant broke his silence and shook hands with her. 'So you are from here only?' Siddhant asked Emma.

'Yes, I am from Paris only, I was here in the club with a friend of mine, but she got some company so I thought of leaving' she replied while still puffing her cigarette.

'Nice. So what do you do Emma?' Ayushman asked her.

'I am a photographer and traveler. I travel to different places and take pictures of that place. After working continuously day and night from last two days, I thought of rewarding myself with couple of drinks and little bit of dance and fun. What about you guys? You came from India for a trip?' she asked both of them after telling them about her.

'No! No! Actually, I have come to France for a course, and Ayush just got done with his course from USA (Just Graduated) so technically, you can call us foreign students.' Siddhant tried to add a bit of humor in his talks.

'Oh, that's great. What course have you opted?' she asked Siddhant very curiously.

'Sound and audio engineering. He is here to learn technical things to produce music. Let me tell you about him, Emma, he is a fabulous singer, and he even got his band back there in India,' Ayushman told Emma all about Siddhant enthusiastically.

'Wow, nice, you are a talented guy, Sid. Now why don't you have a drink with me?' She was impressed with Siddhant and was looking at him while waiting for his reply.

'Sure, Emma, he'll join you. Why don't you start moving? We'll finish up this cigarette and catch you at the bar?' Ayushman replied on Siddhant's behalf.

'All right, I'll be waiting then,' she told them and went and sat near the deck.

'You lucky douche, you are getting laid tonight,' Ayushman said in full excitement.

'Laid? Are you crazy, she's not a hooker or a whore who'll be sleeping with me after a drink in a bar. Plus I don't have such intentions as well.' Siddhant sounded annoyed.

'Chutiye, who said she is a whore? And who the fuck has asked you about your intentions? Just go inside and get along with her. Make friends here you will be needing them during your course. Now take this room key and go talk to her. Try to be friendly but not flirty, douchebag.' Ayushman patted Siddhant's shoulder and signaled him to move.

'Guru ji! I always knew that you'll teach me something someday, ha ha ha.' They both laughed.

Emma was standing at the deck and was looking at the crowd. Ayushman gave thumbs-up to Siddhant and went back to his friends. Siddhant was bit hesitant and shy as this was happening to him for the first time. Emma passed a smile the moment she saw Siddhant coming.

'Finally, you are here, singing boy. So tell me what are you ordering for me?' she asked him in her bubbly and giggling tone.

'I'll have rum and Coke. Shall I order that for you too?' Siddhant asked her.

'You know Paris is famous for Wines. Wanna Try?' And she winked back at him.

'Sure' Sid replied immediately.

After ordering the same drink again and again, both of them were happy high. They were enjoying each other's company. Siddhant's hesitation and shyness vanished by then. Both of them were laughing, shouting, dancing, and just adored each other's company.

'I am bored with this loud music and crowd. Let's go out and sit somewhere less crowded and less noisy,' Emma asked Siddhant, and soon they were out of Wanderlust.

Siddhant really liked her idea of getting out of the club, away from the noise, nobody to interfere in their talks. Both of them started walking in the street. Emma was telling her travelling experiences and the countries that she has covered and that were next in her list. Siddhant had a habit of talking about and remembering his friends whenever he got drunk. So he was telling her all of his child memories, what kind of bond he shared with Aashima and Karishma, what he felt for Ayushman and Palash. How his friends supported him when he opted for music as his career, how he formed his band, and so on. Emma was listening to him

very patiently and calmly. She could feel how much he was attached to his friends. It was his eyes that he said he had so many feelings inside that he wanted to tell; he was failing in expressing himself through words.

'Would you like to come and have some drinks at my room? I am tired of walking and want to use washroom,' Emma asked Siddhant.

'Ya sure, but we can go to my room as well, my hotel is right there in the corner,' he suggested while pointing towards a building.

'That'll be great. I really want to use a restroom, he-he' She agreed to his idea and giggled.

They started walking towards the building, and after five to seven minutes of walking, they were in the lobby of hotel and then entered their room.

'Oh my god! Hookah? I can see you have come here with a proper party mood.' Emma was amazed to see two hookahs lying on the floor. Rather than going to the restroom, which was an urgency couple of minutes back, she started making for the hookah, telling Siddhant she could hold for another five to ten minutes.

After having couple of drags of hookah, Emma went to the restroom. Siddhant was sitting on a couch with an opened bottle of Corona on a table in his left land and a cigarette in his right. He was thinking about Emma; he was thinking that she was such a nice girl, independent and understanding. She knew what she wanted to do in her life; she was clear about her future and other thoughts like these. He heard the noise of an opening door, and he was stunned to see Emma; she was wearing dark maroon Victoria's Secret lingerie. She was smiling and was batting her eyelashes at him. Siddhant was looking at her from head to toe; he was gazing at her so closely

'I think you should not smoke that much, singer.' She walked up to him very seductively and took his cigarette. She turned around and bent over to throw the bud into an ashtray, which was on the floor. Siddhant was aroused on seeing her pure white back and that perfectly shaped ass, but there was something that was holding him back, and he was confused what was happening with him. She turned back at him and gave a naughty smile.

'What happened?' he abruptly asked and realized that he asked the dumbest question in a situation like this.

He corrected himself and started praising her body, which was looking very sexy. Her perfectly toned legs with those milky thighs, her curvy waistline, her flat tummy, and her size 34 that were popping out of her maroon lace demi-cup bra. Siddhant was lost in her deep cleavage; he was unable to take his eyes off from her.

'I've a pretty face too,' Emma interrupted Siddhant, and he pulled his eyes off her.

'Ah! I am sorry, Emma, I don't know, it just happened, I didn't . . . mmm.!' Siddhant tried to explain himself, but Emma shut him up by placing her lips over his.

'Sid? Hello? Open the door' Siddhant woke up with these words; he realised it was Ayushman who was shouting and was beating the door.

'Bhai khol de, we need our stuff, at least let us take other room's key card,' one of Ayushman's friends shouted.

'Sid, open the door I want to pee very badly,' Ayushman shouted at his friend and started knocking on the door again.

Siddhant got out of his bed and found Emma's bra lying on the floor. He gave her the bra and asked her to get dressed while he ran to open the door, wearing his boxers.

'Move, I want to pee.' Ayushman ran into the room and found the restroom door locked.

'Emma might have gone in. Either wait, or you can go to the other room as well,' Siddhant told Ayushman.

'Bhai, you aren't done till now? We were out the entire night. We didn't want to disturb you. and instead of saying thank-you, you are throwing us out of the room.' Ayushman tried to be emotional but started laughing when he saw that Siddhant started feeling bad.

'Was somebody knocking on the door?' Emma asked everybody after opening the restroom's door. She was still in her lingerie and all the boys started looking at her with their eyes wide open.

'Yeah, I want to go, and you guys wrap up your stuff. We are going to the other room.' Ayushman went into the restroom and asked his friends to pack their stuff.

'Sid, I feel like going for swimming, so if you want to join me, I'll be waiting for you in the pool.' Emma winked at Siddhant with a kiss on his lips and exited the room.

'Wow! She is hot, man, hot and beautiful French girl,' Ayushman said after coming out of the washroom. He was excited that his friend was finally a man now.

'Yeah, she is very wonderful,' Siddhant replied; he was blushing a lot.

'Dude, don't fall in love with her. This is not India that you'll fall in love with a girl and she'll also fall for you sooner or later. I hope you are getting what I am trying to tell you.' Ayushman had an inkling that a decent and one-woman type of guy may end up loving the girl whom he slept with for the first time. He didn't want his friend to get hurt as he was aware of his emotional side, that's why Ayushman warned him.

'No, brother, but I am just worried she might get hurt, and I am feeling a bit guilty as I love Krisha. If Emma is fine with everything, then I guess half of my problem will be solved,' Siddhant replied.

'Woo hoo, now that's what Paris does to a guy like you. Welcome aboard, mate, I am glad that you got my point.' Ayushman sounded excited.

Siddhant went to Emma, who was there in the pool in her lingerie. He already had slept with her; he had seen her without clothes, but seeing her in the pool with her wet body and hair, he got a boner.

He got into the pool; Emma was excited to see him as well. She came close to him and placed her lips on his, with her arms wrapped around his body. It was the most romantic thing that has happened to Siddhant; he always had this wild idea of kissing and making out with his girl in a pool.

Both of them were playing in the pool; they were hugging each other, kissing each other, splashing water on each other. They both were having a blissful time together.

'I am flying to Texas tomorrow morning,' Emma told him while they were coming back to his room.

'Oh, would you like to spend your time with us? You can call your friend as well,' Siddhant asked her, though he was not in love with her, but there was some connection he felt with her, and he wanted to spend as much time he could.

She accepted his proposal and told him that she'll be back in couple of hours with her luggage, and she'd ask her friend also and took her leave.

Siddhant was alone in his room as all the other boys were sleeping in the other room after spending an entire night in the Wanderlust club and streets of Paris. Siddhant was thinking about Karishma and Emma, one was a girl

with whom he wanted to grow old with and on the other hand there was this French girl, who he met just a couple of hours, who understood him a which Krisha never did in so many years. He was in a big dilemma of whether he loves Karishma or not. All these thoughts in his mind and Ayushman's words of not falling in love with Emma were moving continuously in his head. He was stuck in his thoughts and didn't realise when he fell asleep.

'Hello, open up!' Emma was back and was knocking the door.

Siddhant woke up from sleep and realised it was already three hours passed since she left. He got up from the bed and opened the door. Emma was there standing at the door with her trolley bag and a travelling bag on her back with a camera hanging on her neck. She gave him a hug and placed a kiss on his cheeks.

'You came alone, where is your friend?' Siddhant asked her.

'No, she has plans with the group and the guy who met her at Wanderlust. So she'll be meeting me directly at the airport day after tomorrow,' she replied while adjusting her hair and dress by looking into the mirror.

'Sorry to disturb you guys, but we are going to the Eiffel Tower, do you want to join us?' one of Ayushman's friends peeped in from the semi-opened room door.

'Yes, sure, give us a moment. We'll catch up with you guys in the lobby,' Emma him and went to close the door. She placed a kiss on Siddhant's lips and asked him to get ready.

Soon they reached Eiffel Tower.

'What a breathtaking view it is man' Ayushmann said and took out his mobile and started taking pictures.

'You want to experience something exquisite?" Emma asked the group

'Of course' Ayushman quickly replied. She took them up on the Eiffel Tower for a dinner.

'Wow' was the one word everybody said when they reached upstairs.

They had an awesome dinner at the Eiffel Tower and then returned to their hotel. Emma and Sid were given one room and rest of the boys adjusted in other room.

The moment they entered the room, Emma started kissing him, and they were on the bed, cuddling and loving each other. Soon both of them fell asleep in each other's arms.

Siddhant opened his eyes and found Emma not in the bed. He got out of the bed to check her in the restroom, but she was not there either. She was nowhere in the room. He thought of checking the pool area in hopes that she might have gone swimming. He went to take the key card and found a note under the ashtray, which was lying next to the key card. He picked it up and realised it was from Emma. He lit a cigarette and started reading the note.

> You are a great person Sid! The time spent with you is unforgettable. I wish I could have spent much more time but I can't compromise my dreams. I didn't want to see your sad face while seeing me off, that's why I didn't wake you up. Hope I'll meet you again in some other corner of this world, Take care of yourself. I know I was the first girl you slept with, and I also know that you feel for Krisha. I wish you all the

best for your future, and I'll pray that you get what is best for you, Sometimes in life we run after a faint light ignoring a full lamp kept near us.

Think about what I just said.. It was great knowing and meeting you.

Love!

Emma

My E-mail- emmajtraveler_15@hotmail.com

Siddhant loved the small gesture from her. He had a smile on his face, but his eyes were moist. He was thinking an unknown girl, who he met just a day back, understood him. Siddhant questioned himself of 'what does he wants in life', but he didn't get any answer.

Finally their trip was over. Sid dropped Ayushmann to the airport as he had to join his family in Florida. Sid bid good bye to him as he was supposed to join his college from the next day.

* * *

Aashima was having a grand time with her family and fiancé. They had visited Washington's and Boston's tourist attractions and some of their relatives as well. The next on their list was Disneyland, Florida. They had a two-day stay in the land of Mickey Mouse.

Ayushman joined his sister and family at Orlando Sanford International Airport, Florida, and from there they have an hour ride to Disneyland. All the way from airport to the hotel, Aashima was teasing her brother by not calling him by his name but Mr. Graduate.

After travelling eighteen miles from the Orlando Sanford International Airport, they were finally at their hotel—Walt Disney World Resort, Orlando. Everybody was so excited after seeing that luxurious hotel. Aashima insisted everybody to pose pictures as she was mesmerized by the beautiful landscape around the hotel. They checked into their rooms, and after resting there for a while, they decided to go outside the Disneyland.

Aashima was very much excited for their Disneyland visit; it was like dream come true for her as she wanted to visit there since her childhood. She was amazed to see everything. She was not bothered about the long queues for the rides as she was damn excited about everything in that place. Palash and Ayushman were the victims of her madness as they were forced to stand in the long, snaky queues and had to wait for several minutes for their turn to be on that ride.

'Let's go to Hollywood Towers over there, I've heard a lot about it.' Palash sounded very much excited about that ride and dragged both Aashima and Ayushman towards it.

Hollywood Towers, a huge lift that starts from thirty-fourth floor, goes up and then comes back to the ground floor with a full-impact force. The three of them went up to the entry of the ride on the thirty-fourth floor from elevators and were amazed with the view they saw from there. Aashima had a phobia of heights, and she was scared of going on that ride, but after Palash's and Ayushman's continuous naggings and requests, she agreed. She sat on the seat of the ride which was between her brother's and fiancé's seat; fear could be seen easily on her face. Both the boys were laughing looking at her.

'Ha ha ha! Don't behave like a fuddu, Aashi! Be a brave girl.' Palash started laughing and he was joined by Ayushman.

'Could you please shut up? I don't want to sit on this ride. Let's get up,' she said in irritated and scared tone and tried to take off the seat belt.

Aashima was about to say more when the lights of the ride were turned off and countdown started—three, two, one . . . GO! And *boom*—the lift went up with a full force. Aashima started shouting as loud as she could, her eyes were closed and head was down. She was holding Palash's arm very tightly, and all her nails were digging into his skin. The ride stopped on the tenth floor, and she had a sigh of relief.

'Phew! Thank God' Aashi said, taking a deep breath.

'Hahah!' Ayushman gave an evil laugh.

'What? You dog! I'll—' She tried to say something to Ayushman, but before she could complete, the ride went up again with more force and in faster pace.

After spending five to seven minutes moving up and down on that ride, they finally landed on the ground floor; and the moment Aashima was freed from the seat belt of the ride, she bolted out as if somebody was after her life. She was shivering and was looking horrified. Ayushman and Palash were unable to stop their laughter seeing her like that.

'Fuuuck, man! That was insane,' she shouted while gazing at the ride with her terrified eyes. The boys were still laughing at something, which irritated Aashima more as she thought no one was bothered about her.

'What? Why are you laughing?' she asked furiously and went up to them.

Palash and Ayushman were looking at a picture which was taken when the ride was going down. Aashima was

looking risible. Her hair was in the air, mouth wide open with tongue coming out, and that fear in her eyes were all together making that picture bizarre.

'Now that's it! When did they take this crappy picture? Seriously, I am done with this place now,' she shouted out of her anger and irritation. She never looked that afraid as as he was looking in that picture.

Aashima saw a weird devilish smirk on Ayushman's face. She knew something mischievous was going on in his head, but she was not able to figure it out. She was trying hard figuring out what her brother was up to, and soon she realized what it was when she saw him taking out money to buy that picture.

'Don't even think about it,' she shouted at him without realizing that the entire crowd was staring her; but it was too late for her as Ayushman had bought that picture, and he started teasing her by raising high it in the air.

Aashima jumped to grab the picture, but failed and then started running after her brother shouting. She knew that he'll publicize the picture and will tease for life; she wanted to tear that photo. Ayushman went straightly to his parents, who were sitting in a coffee shop, followed by his sister and would-be brother-in-law. And they all started laughing looking at the picture, and Aashima was sitting with her angry face.

Soon it was dawn, and the entire Disneyland was covered in beautiful coloured lights. All of them were waiting for Disney light and sound show, and the moment it started, they all got dumbstruck with the scene. They were mesmerised by the breathtaking show with beautiful fireworks, remarkable and amazing songs with story line.

After watching that beautiful show and the quality time in that beautiful theme park, the parents decided to go back to the hotel.

'Can I take Aashima out for a dinner? I have planned something for her,' Palash asked her parents. Aashima was not expecting something like that; she was surprised to know that her would-be husband has planned something for her.

Her parents gave a smile to both of them and nodded their head 'yes'. Ayushman called a car and left with his parents while winking at his sister.

Palash made a call to somebody, and Aashima was looking at him with doubt and fear in her eyes that he'll do something that will haunt her entire life. They waited for a while at the gate of the park, and soon there was a limousine standing in front of them. Palash went up to open the gate and ask her to get in the car while sitting on his knees. Aashima was speechless; it was totally opposite to what she was thinking.

'O my God, Palash,' she uttered with her hands on her cheeks, which had been turned red from blushing.

Palash extended his hand, and Aashima was overwhelmed with all this. She held his hand and got inside the car, which was decorated with heart shaped 'I Love You' balloons. The car started moving, and Palash took out two wineglasses from the cabinet and poured red wine into them.

'This all so romantic, Palash, I've never felt this special,' Aashima told him with glittering eyes.

'The night is not over yet,' Palash replied very romantically while sipping wine from his glass. Aashima didn't show, but she felt something electrifying after hearing him.

Soon they reached their destination. The doors of the car were opened by Mickey Mouse, who was wearing a chef's coat and hat

'Hello! Welcome, ma'am!' Mickey greeted Aashima with a bow and guided her to their table. That was unbelievable.

Aashima was awestruck after seeing the arrangements that Palash has done for her. There was a table with a candle stand in the middle, with plates and wineglasses. The chairs had carvings of mostly all the Disney characters, like Mickey Mouse, Donald Duck, Pluto, Mini Mouse, and others. It was like an entire cartoon movie was engraved on those chairs. The most amazing thing that she totally in love with that place with amazing Disneyland castle's view.

Both Aashima and Palash were talking to each other about their future looking into each other's eyes, with his one hand on Aashima's hand. It was their lovey-dovey time. They so wanted to be together and spend time like that for so long. After all, having a long-distance relationship is not that easy; you have all sorts of trouble, doubts, eagerness to be together, all at the same time.

After dinner, they left that beautiful and dreamy place. They were not talking much on their way back; it was their eyes that were speaking on their behalf. The car stopped at their hotel's gate to drop them off. Both of them were lost in each other's eyes, which were shouting loudly that this couple is madly in love with each other. They came closer, and their lips met for the first time. There was a current of a thousand volts running through their bodies, from head to toe, when they kissed each other. Their bodies got warm, their breaths got heavy, and they continued kissing each other. A kiss is a lovely trick designed by nature to stop speech when words become superfluous. Aashima could feel

the rapid heartbeat of Palash, and she could taste of apple crumble pie, which they had for dessert, on his lips.

They got off the car and reached the door of their rooms; she was staying with her parents, and he was sharing his room with Ayushman. They looked back at each other.

'Thank you for this wonderful evening. This will remain special to me forever,' Aashima said and placed a kiss on his cheeks before going into her room.

She was smiling and giggling the moment she entered her room as if somebody was tickling her. She was happy; she was still in the moment when they were kissing each other. It was again and again flashing in front of her eyes. She changed her clothes and lay down on the bed, still lost in Palash's thoughts and the beautiful evening.

* * *

'Pops, we are leaving, you sure you guys don't want to come with us?' Aashima asked her dad.

They were back from Florida back to Brooklyn. It was their last day in the States, so they had planned to out for bit of shopping. Her parents wanted to stay back and rest, so she went out with Palash and Ayushman. Like every girl, Aashima sounded very much excited about shopping, and Ayushman was looking that much scared as his sister was behaving like a maniac from the moment she heard about shopping.

They went to all the stores on Fifth Avenue. Aashima purchased few things from Hollister, Banana Republic, and lot others. Palash took her to Macy's; he wanted to get her a watch. Aashima liked a Bulova watch, and they purchased it. Palash was happy to see her happy.

After shopping, they came back to their apartment.

Palash helped Aashima, her brother, and her parents in packing up their luggage. Sadness could be seen on Aashima's face. She knew it was the last night with Palash, and she was not sure when they will see each other next. After packing, they all went to sleep.

Aashima was rolling on her bed with thoughts of going away from Palash, when suddenly she heard a knock on her room's door. She opened the door and was surprised to see Palash at that hour of the night. He moved forward and hugged her. Aashima burst into tears. The hardest part of separation is being unaware of when they will meet again.

'Don't cry, I'll be coming soon,' Palash promised her and planted a kiss on her forehead.

They stayed there standing, hugging each other for a long time, Aashima didn't want to Palash to leave her. She was getting comfort in those arms that were consoling her.

Finally, they left in the morning and reached India after travelling for twenty-two hours. Aashima had best time of her life which she is cherishing.

Chapter 16

'Too Often, the only escape is sleep'

Next morning, Aashima could hear someone shouting her name at top pitch. She opened her eyes and realized that it was a familiar voice, but she was so dizzy she was unable to make out who was calling her name, until she saw somebody standing in her room. She tried to open her eyes and could barely see that it was a girl, but when she said her name again while shaking her up, she knew who it was—Karishma.

'Oh, hi,' Aashima said in her dizzy tone.

'What is this? You are meeting after such a long time and just a *hi*? Stand up you lazy butt,' Karishma shouted and removed Aashima's quilt.

Aashima started laughing and raised her hands to hug her. 'How have you been?' Aashima asked Karishma.

'Everything is good, but first, show me what you have brought for me from the US?' Karishma asked very enthusiastically.

'Haha! Are you crazy? I landed last night, I haven't unpacked yet, but I am sure you'll like what I've brought for you,' Aashima replied.

'Wow! I am excited now. What brands did you get for me by the way?' Karishma's excitement could easily be heard in her words.

'Relax, Krisha, wait for some time,' Aashima said and added, 'How was your trip? Where did you go?'

'We went to Shimla, it was so chilly,' Karishma replied.

'So, are you guys dating?' Aashima asked.

'No, actually it's kind of complicated, I am not sure,' Karishma replied while making a sad face.

'What do you mean by that?' Aashima was already feeling bit dizzy and a statement like that from Karishma just went over her head.

'See, Rajat and I feel that we have some connection, but we want to give each other some time to know if that is connection is love or not. That is why we planned the trip, to know each other more closely.' Karishma started explaining her statement.

'Okay, carry on.' Aashima asked her to continue.

'Hmmm, so we took two separate rooms there in the hotel. The first day I wore a beautiful pink shirt—you know, the one I have that looks good on me. But the whole day he never complimented me and kept on looking at himself in mirror wherever we went, adjusting his hair, his shades, and his T-shirt. Then in the evening, we thought of going to the Ridge, so I changed and wore a black-coloured dress. I thought he'd like to see me in that dress and would definitely compliment me, but he didn't and asked me what brand I was wearing. I was like, "I am looking good and he should appreciate it," but all he considered was what brand I was wearing! Can you beat that?

You know, Aashi, he himself was wearing a pathetic Puma T-shirt, which was clearly looking very shabby. And

over it he was wearing a jacket with AJ written on it. I complimented him that he was looking good, and he replied "It's Armani, my brother-in-law and sister had brought this for me from Italy," and I was like "Dude, I'm complementing you, not your cheap imitation clothes." The next day I was wearing a Hollister jacket, which Ayush got for me once. He doubted me the whole day, trying to check whether it was original or fake. This was so irritating. I am not like him who wear fakes. If I have original, I will wear it. Otherwise, I'll save.' Karishma was talking continuously, without even taking breath breaks.

'Wait a sec, and you think you have a connection with this guy?' Aashima interrupted.

'I don't know, I am very confused, yaar. He is very nice and sweet but it's just—' Karishma got interrupted by Aashima again before she could complete.

'Krisha, please, you know I don't like such two-faced guys. Think once again.' Aashima sounded irritated and pissed.

Karishma tried to say something but suddenly her phone rang; it was Rajat calling.

'It's him, Aashi, it's him. What shall I do? What shall I tell him? I made an excuse to him as he wanted to meet me today, and if I'll say that I am here at your place to meet you, he'll get mad and upset with me.' Karishma was paranoid.

'Why do you have to give him excuses? Why are you answerable to a guy who is just your friend not even boyfriend?' Aashima was on the verge of temper.

'Should I message him that I am with Mom?' She ignored what Aashima just asked her.

'Seriously it's your choice,' Aashima replied irritatingly.

Aashima stood up and went inside the washroom to stop herself from bursting on Karishma. She locked the

142

door and started cursing herself of why she stayed at home. She thought of where she could run. She just wanted to be done with Karishma for the day as she was already tired physically after so much travelling, and Karishma has taken over her mental peace as well now. She washed her face to calm herself down and came out of the washroom.

'I've told him that I am at my doctor's. I had to get my eye test done,' Karishma said upon seeing Aashima coming out.

'Okay good!' Aashima gave an uninterested reply and started opening her luggage.

'What are you doing?' Karishma asked, keeping her phone aside.

'Nothing just unpacking the stuff. I'll show you your gifts as well. Sid has also sent few things for you,' Aashima replied without looking at her and controlling her anger.

'Oh my god, I am excited. Did he send those bellies that I've asked of him?' Karishma asked.

'Yes, here are your bellies, and this top that Sid sent. And here are what we've got for you.' Aashima handed her the packets and the belly box which she has brought for her.

'Oh! Aren't those too bright, and what brand is *Vinci*? I asked him to send me Aldo bellies,' Karishma told Aashima with disgusted facial expressions when she opened the belly box.

'What are you talking about? Bellies are looking perfectly fine. He tried so hard to get the best for you, and you are talking about brand? Don't tell me that you haven't heard of Da Vinci - Its an Italian brand' Aashima replied sarcastically.

'No, but I've asked him to send me a lighter orange. These are too bright. I am not sure where I'll wear it. The

top is nice though. I am sure that you might have helped him out buying that top for me.' Karishma said while giggling, and Aashima was getting irritated hearing those giggles.

'No, Karishma, Sid went on his own as he wanted to shop for you on his own.' Aashima's irritation could be sensed in her tone now.

'I wish you would have gone to shopping with him,' Karishma said with sadness in her tone and face. 'Hey did he get you this weird out-of-fashion watch? What brand is it?' she continued while holding Aashima's watch and was trying to figure out what brand it was.

'It's Bulova, and it was a gift from Palash, and I love it.' Aashima was on top of her temper.

'Oh! Nice. I liked all the gifts that you brought for me. Thank you, Aashi.' Karishma diverted the topic with her soft tone and gave a hug to Aashima. But Aashima had a big doubt that she really liked the gifts or she was just pretending.

Aashima waited for Karishma to ask about Palash, Siddhant, the graduation, or her trip; but the entire evening, she was busy with herself and was least concerned about others.

Karishma's phone rang again, and she showed it to Aashima. It was Rajat calling her again. Before Aashima could say anything, Karishma said she has to go and bid her goodbye. Ashima was amazed to see that nothing can change her. She thought for a while about her but then took a wise decision—go back to sleep that was the only thing that could relax her that time. She again slept forgetting all the worries of the world because sleeping was something she enjoyed and loved. I mean who wouldn't love to sleep in this world.

She decided not to even try the next time.

Chapter 17

Marriage on the Cards

It had been two years since Aashima and Palash were engaged, and finally, marriage was on their cards. Palash was permanently back to India and has switched company; now he was working as a manager at Adobe, Noida. Their marriage date was fixed, and finally, Aashima could see her.

Siddhant's studies were over, and he was coming back to India as well. He was trying to establish his own recording studio and label with a friend, Punit, who he met in Paris. Both of them were pursuing the same course. Punit's dad was a well-off person, and he owned a media house and was helping his son and Siddhant in establishing their work. Both Siddhant and Punit were equally passionate about music, where Siddhant got his vocals and music sense, Punit was good in composing music and sound arrangement. Siddhant was very happy about his venture and was working hard over it.

Ayushman was working as the chief executive of Sales at Coca-Cola and was enjoying his corporate life.

As the date of marriage was coming closer, Aashima started getting nervous and conscious about everything. She

started getting irritated if one tried to tease her by talking about her wedding.

The wedding preparations started; everyone was busy in their work that was assigned to them. Aashima wanted to choose her wedding invitation on her own, so she asked her brother to take her to the designer, and he agreed. Both of them went to a designing shop at Kinari Bazar, Chandni Chowk, accompanied by Karishma. Aashima was very excited, she wanted to select each and everything for her wedding: from her dress to jewellery and from decoration to cards. And she wanted everything according to her specifications. They went to the shop and started looking the various card designs.

'Wow, this is classy and elegant. It's really very beautiful.' Aashima fell in love with a red and golden-coloured card after looking at five or six cards.

'Isn't it too expensive and too glittery? I don't think that is classy. Check this one out. It looks fabulous, and it's less cheaper.' Karishma was holding a brown-coloured dull card, which had blue and green peacock design over it.

'Did you just differentiate these cards on their price? Ha-ha, only Rs.2 difference. What happened to you, Karishma? You liked the brown card more?' Ayushman was too blunt to handle.

Aashima gave her brother a dead stare to shut up, and he stopped giggling.

'No, it's not like that, Ayush, I was just generally saying. Let's keep the card selected by you Aashi at one side and check some more designs. Bhaiya aur designs dikhana.' Karishma explained herself and asked the vendor to show them some more cards.

After spending forty-five minutes at the shop and going through more than one hundred card designs, both Ayushman and Aashima were tired and irritated. Karishma was taking out all the dull shades and was praising her each choice.

'Karishma, I liked the red one, the one we kept on the side. Let's finalize that. After all, marriage happens only once.' Aashima moulded up her irritation and frustration into sugar-coated words so that she doesn't end up hurting her.

'Ya! Ya! Even I think that one was better, the rest are not that good.' Karishma tried to cover up.

So the card was final, and still they've got a whole list to cover. Ayushman ticked out 'Cards' from the list, and the next thing that was there was Aashima's bridal clothes.

'No way! I can drive you two wherever you want to shop your wedding lehnga, but don't expect me to come inside the shops with you. You two get crazy while shopping,' Ayushman shouted when he read that the next on the list was his sister's wedding clothes.

'Ha ha ha! ok, you don't come inside. Now drive us to South Ex.' Aashima started giggling while Karishma was busy on her phone.

Ayushman drove them to South Ex and dropped both the girls near the market. Aashima was sure in her mind about what kind of bridal lehnga she wanted. She didn't want to go for anything blingy or glittery. She didn't want to look like lightened candle and sparkle like anything. She wanted an elegant lehnga for her in bright red colour with a combination of green colour.

'Come on, Aashi, you are sounding like aunties. Don't keep any design or colour in your mind. I'll pick a great lehnga for you where you'll look the prettiest bride ever,'

Karishma replied after hearing Aashima's idea about her wedding dress.

Aashima got scared and worried after hearing Karishma. She was just staring at her and was questioning herself, *Why did I call her for the shopping?*

They went to many shops, and Aashima tried so many lehngas, but she didn't like any and; on the other hand, Karishma liked plenty of them She tried her best to convince Aashima of various lehngas, but Aashima didn't want to wear something that was imposed on her. She wanted something elegant and something like the design that was in her mind. After all, it was her wedding.

The wedding date was only one month away, and still Aashima's wedding dress was not finalized. Both Aashima and Karishma were hunting each and every market of Delhi in search of the lehnga like the one Aashima needed. Then finally, Ayushman came up as a saviour.

'I come to know about this designer. She'll design your lehnga according to your idea. We can go to her. If you want, I can talk to my friend who knows her, but only we two are going. No Karishma this time. Dimag kha jati hai aur kaam bhi nahi hota.' Ayushman told his sister with an irritation for Karishma in his voice.

'Ha ha ha! Finally, you are charmed with her charm, ha-ha.' Aashima giggled, and she asked him to make an appointment with the designer.

Finally, they were done with Aashima's wedding dress. The designer came up with a beautiful design as per Aashima's idea and colour combination, and the final lehnga came out to be exactly what she wanted. Blood-red coloured with green and golden kudan design on it. She was very happy to see her wedding dress and was impressed with

the designer as she had given her the exactly same lehnga that Aashima sketched on the paper.

The marriage date was coming closer, and all the preparations were going on in full blast. Ayushman and her parents were busy in distributing cards and inviting their relatives whereas Aashima was going with Palash and his mother to shop for jewellery. Out of all of them, the busiest of them all was Karishma. She was busy asking questions and answering herself on topics like What to wear on the wedding? How will Rajat react when she'll tell him that she's going to stay at Aashima's house? Will she'll look hot on every function? And so on.

On the other hand, Siddhant wrote a mail to Emma telling her about his flight timings and telling her how excited he was as he was going back to his home, going back to India. He told her to take care and he will send him pictures of the marriage.

Siddhant was coming back and was touching down in Delhi just two days before the marriage functions to get started. He was excited as his best friend was finally tying the knot with the love of her life. He always adored the couple and their commitment towards each other, living in two different countries but still close to each other, without any hustle and clash. He was happy that his friend has got such an understanding and caring life partner who'll always keep her happy.

Chapter 18

I was too Blind to see that you were too Deaf to Hear Me

Aashima was leaving for New Zealand for her honeymoon and was at her parents' house with her husband for pag phera, a post-marriage ceremony in which the newly married bride comes back to her father's house and spend some days there. The bride's brother comes to her in-laws' house to take her back for this ceremony. Palash's home was in Pitampura, so both Aashima and Palash decided to leave for the airport directly from her parents' house in Paschim Vihar rather than going back to Model Town. Before leaving for their honeymoon, Aashima wanted to meet Siddhant and Karishma as it has been couple of days she hadn't talked to them; she was kind of missing both of them. So she asked both of them to come over her place for dinner.

Karishma got excited when she heard Aashima asking her to come over as she wanted to meet her before them leaving and wanted to share so many things. Karishma agreed and told her that she'll be there at Aashima's home soon, until she got a call from Rajat. He called her to tell

her that he was missing her and wanted to see her as it has already been a month that both of them haven't seen each other due to Aashima's marriage. She was in a huge dilemma of what she should choose—her childhood friend, who wanted to meet her before starting her married life or a person whom she didn't like that much. And soon Karishma chose her childhood friend, not for the purpose of meeting her but on the basis that she'll understand her. She convinced herself in her mind that no matter what happened, Aashima will understand her and will always stand for her.

```
Krisha                        Hutch

I'll get a bit late. Going
to meet Rajat, he is so
desperate to see me. I will
catch you at dinner
sweetheart.
            Options
```

```
Aashi                         Hutch

Whatever it is, be on time,
it's Palash who has made
the dinner plan, I don't
want to upset him.

            Options
```

Yes, Aashima got angry, and she was hurt upon reading Karishma's message. She wanted Karishma to be with her, but she chose a 'nobody' over her. She controlled herself as she didn't want to spoil or disturb the happy moments that she was cherishing with her family.

Siddhant reached her house, and everybody got so happy to see him, especially Aashima. No matter how much you are laughing or having great time with your family, you'll always have got this special feeling when your best friend is around you, which Aashima was experiencing.

'So, have you told about your feelings to Krisha? I am dead sure that you might have tried and she didn't show her interest in even listing to what you were trying to say,' Aashima asked Siddhant after talking about various moments about her wedding celebrations and other things, for about half an hour.

'No! No! It didn't happen like that. I opened my heart and told her about my feelings for her, which I had from past so many years. I told her how much I care for her and how much she matters to me in my life. She listened to everything very calmly and understood everything that I told her. We even had a little kiss on your wedding day as well, and ever since, we are talking to each other all the time—on messages, late-night calls,' Siddhant interrupted Aashima.

'What? Are you serious? Don't tell me, Sid, if all this had happened, then why the heck has she gone to meet Rajat today?' Aashima was surprised after listening to Siddhant. She did not believe him as she very well was aware that Karishma was involved with Rajat, even if she doesn't show that in front of anybody.

'What the fuck are you saying? She told me that she was going to Aunty as she wanted to get some gift for you. Are you sure that she is with this guy?' Siddhant was confused.

'Why would I lie to you? You can see on my cell phone, she dropped me a message. I am myself so confused right now. Did she say anything to you about her feelings towards

you or something?' Aashima was perplexed and asked Siddhant.

'Mmm, no, I mean she didn't use any word to express her feelings. She just gave me a smile and a hug when I told her about my feelings. and she used to say even you don't know What's the feeling and even i don't know, So, lets give this feeling som time. And after that we are constantly talking on phone. I tried to get naughty sometimes, little bit of sexting and some cheesy lines. She never felt offended or raised any objection, and in fact she reciprocates.

Siddhant was sitting quietly after that, without any words and without any thoughts; he was totally numb. All he wanted at that moment was to go of Aashima's house and smoke a cigarette, but he couldn't as Aashima would get mad at him. On the other hand, Aashima was thinking hard to figure out what Karishma actually wanted to do. On the one hand she was talking to Siddhant like this and on other she was meeting Rajat. What was she thinking ? Aashima didn't want Karishma to hurt Siddhant at the end as she knew he had developed such a strong feelings for Karishma, and it would be difficult for him to control his feelings if this thing continued.

And on the other hand she was somewhere worried for Krisha as well who was behaving in such a weird manner. She was worried why is she doing all this.

Aashima tried calling Karishma a couple of times from the other room, but she kept on disconnecting the call. She decided to talk to Siddhant and would tell him everything she knew—and he didn't—about Karishma so that he could get a clear picture of what was happening.

'Listen, I have few things to tell you about Krisha that you never knew,' Aashima said,

'What? Why are you behaving like this? What happened?' he was confused after hearing her.

'See, Karishma is a very practical girl who wants a handsome and well-off guy in her life whom she can show as a trophy to everybody. She'll always choose somebody who's leading a professional life. Talent stands nowhere on her list. She'll go for a man who is settled in his life and can fulfil her wishes, and she thinks Rajat is the right guy for her. She didn't come today as Rajat called her. She didn't come to airport to drop us as she was out with Rajat and went for a trip with him to Shimla,' Aashima said without taking a breath, while Siddhant was listening to her without uttering any word and with sadness in his eyes.

'I am not against her. She is my best friend, and so are you. I would never want any of you getting hurt any point of life. I don't want you to end up to be a fool who didn't know anything or unaware about what is going on. I can see the future right now, and I am seriously afraid to see in you in that mode.' Aashima continued talking, and Siddhant was still mum, listening quietly to whatever she was saying. He was broken from inside; he was feeling like a rug that they use only to clean dust of their shoes. He could recall everything in his mind now: Karishma talking to him when she doesn't have anybody to talk to; she ignored him when she was out with somebody, which could be Rajat now; lying to him every time; and several other things were going in his head.

'Where have you gone, Sid? I am talking to you, are you listening or not?' Aashima shouted at him, bringing him back to his senses.

'Ya! Ya! I am just here. See, I know how she is. I had an idea of her flings. I know about her past, but still there is

something that pushes me towards her. The harder I try not to think about her, the more I feel attached to her. I don't know why I have this feeling, but seriously, I'll wait for her until she ties knot with somebody else.' Siddhant replied. He sounded heartbroken;

'What? Did you just say what I heard? Are you insane or out of your mind? Why the hell are you behaving like this? Stop talking like Bollywood actors, "I'll wait for her forever", stop being childish and think for yourself if she is that worthy for you and your waiting.' Aashima had completely lost it and was blabbering whatever thoughts were coming in her mind. She was walking here and there in the room while talking and was making funny facial gestures in her anger, which even made Siddhant laugh for couple of times, but he dropped the idea to laugh in front of her in that heated environment. While both Aashima and Siddhant were busy in shouting and listening respectively, Palash entered the room after hearing his wife yelling at somebody.

'Come here and meet this guy. You know what he wants to do?' Aashima held Palash's hand and dragged him toward the couch where Siddhant was sitting and she was still shouting at her highest pitch.

'What happened? Why are you yelling so much at him? What's the matter?' The cared and confused husband asked his wife.

'He wants to wait for a girl till she gets married and wants to get hurt each and every day. Can you beat this?' Aashima told Palash; she was still holding his arm and was still shouting. Palash was still very confused, unaware of what was happening and how he had to react. He looked at Siddhant and asked him what's wrong with his wife using

facial expressions, and Siddhant signalled him with to stay quiet in the same way.

'See, Sid, always keeps this in mind that sometimes you just have to turn the page to realize there is more to the book of life than the page you are struck on. Now stop being afraid to move on. Close this chapter, and never re-read it again. It's the time to get what you deserve in your life rather than staying with those things that you don't deserve. Don't waste your time and days on the things that you are not meant to do. Just let her go and just concentrate on your future.' Aashima completed her speech and felt happy after giving her friend a 'wise advice'; she was feeling proud of showing off her 'Gyaan' in front of her husband.

'Wasn't that the line from the article that I was telling you?' Palash said after her wife was done, and the very next moment, he was standing with fear on his face and apology in his eyes when his wife gave him a dead stare.

The entire serious discussion was turned into a funny rumble. After listening to Aashima, Siddhant was out of thoughts and words. He was wondering why on this earth she reacted like that. He was wondering that whatever she just spoke was nothing related to his situation

'Abe ladhke sabb chodh, Kaam pe dhyan de, shadi to sabki ho hi jaati hai ek din. Don't you worry, mate, Sabb sai hai. Life should be Tana Tann always.' Palash patted Siddhant's back and looked towards his, wife who was still staring at him with anger.

'By the way I heard about this girl, Emma,' Palash whispered in his ears so that it doesn't reached Rani Jhansi. Sid just blushed a little and thought he was not expecting something like that from him either. It was clear to him that this is the perfect match to be paired as both of them

tried to explain to him something that was not related to his situation.

'Why don't you start taking up brainwashing sessions in which you force people to think what was the problem at first place. You just explained to me something that was completely out the box.' Though Siddhant pointed at Aashima, his aim was both the husband and wife.

Aashima was not expecting such response from him, but when she got a totally different reply, she got even more furious. She grabbed a pillow that was lying on the side and headed towards him. It was clear that she'll rip Siddhant's ass it was right there on her face.

'You are dead now,' Aashima shouted while moving towards him.

'Calm down, calm down. Peace! Peace!' Palash jumped in between to stop her.

'All the best, sir ji, you'll be handling this trouble lady throughout your life,' Siddhant sarcastically said while puffing his cigarette.

'Ha ha ha! I guess I've got a defective piece. On our wedding, everyone was smiling and laughing at the time *doli*, while we were leaving. Is she the problem child of the house? Have you seen this movie *Problem Child*?' Palash asked while giggling.

'Yes,' Siddhant answered him in one word with a wicked smile on his face.

'Sai hai, Sahi hai ladhke,' Palash replied.

Siddhant was amused to hear such a reply from him, He was praising god for pairing them together and was giggling on his own. 'So when are you guys leaving?' Siddhant changed the topic and controlled his giggles.

'We'll be leaving around 2.00 a.m., and we have so much stuff to pack up. You carry on with your cigarette, I'll get to my wife, ha-ha,' Palash replied and went inside the house running.

Siddhant was busy smoking and thinking about the things that had just happened. He left saying bye to everybody.

Ayushman came and went straight to his sister's room where she and her husband were sitting on the floor with a big suitcase opened in front of them. Aashima was taking out her clothes from her closet that was there at her parents' house, and Palash was adjusting all the stuff in the suitcase.

'Here you go, and from now onwards, ask you husband to get all these stuff on his own,' Ayushman shouted the moment he entered the room and dropped all the bags on the floor.

'Thanks so much, bhai, you are the best,' Aashima replied in her overly sweet tone.

'What is this?' Palash was confused.

'I needed few things and couple of clothes,' she replies in a dismissive tone.

'We already have so many clothes to pack in our bag, why are you carrying more of them now? Palash sounded worried.

Aashima didn't reply and pretended that nothing was asked from her and exited the room.

'This is just the beginning, my friend, please continue with your packing.' Ayushman patted his shoulder and exited the room as well after his sister, leaving behind the poor guy to pack all the stuff on his own.

'You should have at least answered him,' Ayushman started giggling.

'After marriage, it's wife who decides what to question and when to answer,' she replied and started laughing loudly.

'This thing is not allowed in my house. There are few protocols that you have to follow from now onwards, and answering your husband is there in the protocol list,' Ayushman said with a smirk on his face. Aashima was at a loss for words; she was astonished to hear what her brother has just said. She stared at him with her raised eyebrow.

'What do you mean by protocols and your house?' she asked him.

'Ya, my house. Your house is now in Pitampura. Now whatever you want to do in this house, you have to take my permission. If I'll grant you the permission, only then you are supposed to do that.' Ayushman was teasing his sister, and before he could finish the sentence, Aashima gave a tight pat on his head, and soon both of them were running all over the house. She was asking him to stop, and he was provoking her by asking, 'Catch me if you can.'

After the hustle and brawl for ten to fifteen minutes, both of them got tired and sat on a sofa; they were breathing heavily and were constantly laughing and thinking that they'll remain like this forever. She had this feeling that she was blessed with the best brother that anyone could have.

'Please take care of yourself and Mummy and Papa, you stupid,' she asked her brother in a very emotional tone and little moist eyes. She was expecting something emotional to be coming out of her brother's mouth, but the reply she got was totally beyond her expectations.

'Tum kya leke aaye the? Aur kya leke jaoge?' Ayushman replied very casually, and Aashima stared at her. She gave him the stare of her life.

'What did you just say? Is there anything in your head? Kuch hai ya all gone?' she asked him while patting his head with her hand. She made fun of him, and they had a hearty laugh together.

'You are here, and I was looking for you in other rooms. Come to the room, Aashi, we have to get done with our packing as we have to leave for the airport on the time.' Palash entered the room where both brother and sister were sitting. Aashima looked at Ayushman and asked him, 'Why did he come?' through her facial gestures.

'I am, coming and why are you so worried? We've still got time, it's just 4:30 p.m., and our flight is scheduled for 2:00 a.m. Stop worrying now

They were still sitting on the sofa, and Aashima was feeling nostalgic now. She knew she'll miss her house, her parents, her brother, and her friends with whom she could talk at any hour of the day till now, but now things would not be the same. Her eyes were watery, and one could easily figure out sadness on her face.

'I am wondering if I could break the wall between your and my room and make it a huge master bedroom for myself.' Ayushman tried to divert her mind as he could sense his sister getting emotional.

'You are dead now, you rat,' she yelled at him. Ayushman actually succeeded in diverting her mind by sacrificing himself. She grabbed his T-shirt and started hitting him when suddenly Palash re-entered the room.

'What hell is going on here? Grow up, you girl. This is not the way to behave,' Palash said in an irritated tone, and the moment he drew his eyes from her, Aashima took out her tongue to tease him.

'I saw that, ha ha ha!' sAyushman said, and the brother-sister duo started giggling.

Finally it was time for Aashima to leave for her honeymoon. The cab was on the door, and they were good to go. Aashima hugged her parents and her brother. Aashima was feeling very sad and wanted to cry badly, but she held herself as she didn't want to cry in front of everybody.

The moment they got into the car, she burst into tears. It takes a lot of courage for every daughter to leave her family and everything which was hers before marriage and shift into a new house and start a new life with a new family.

'You are just twenty minutes away from your house, you can go there anytime,' Palash tried to console and gave her side hug.

'There is a huge difference in being there and being twenty minutes away from your house,' Aashima replied while sobbing.

'It's okay, come on, have some water.' Palash laughed and passed a bottle of water.

While the cab was moving out of the lanes of Paschim VIhar, Aashima was recalling her memories by looking out of the window. 'This was the place from where Papa used to take me for ice cream. Here, I and Mama used to come to buy vegetable.' She was telling all this to Palash in very sad tone and while sobbing; she was being too emotional. She realised that all those moments, no matter how very little, were so special to her.

'Don't overreact now, and please stop crying as I am feeling bad now. Why are you thinking about the past? Think about tomorrow. We are going on our honeymoon, you and me, alone to a place where there will be no worries, no tensions, and no acquaintances, only you and me. Aren't

you excited about this, Aashi?' Palash tried to cuddle her and tightened his hug.

'I'll be fine, don't try that hard,' Aashima wiped her tears and replied. She placed her head over his shoulder and started thinking about her family again, without expressing her feelings through her words. And soon Aashima flew to her honeymoon with her man, leaving behind the worries, and especially Karishma and her problems.

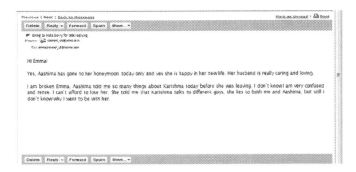

After Aashima's attempts of making Siddhant understand that Karishma was not the right girl for him, he was still talking to her with the same hopes of being with her in his heart. He praised her beauty, her looks, the way she talked and every minor thing that he has noticed about her. Karishma was enjoying the attention she was getting from Siddhant. She enjoyed talking to him as he was a person with whom anyone could talk for hours without getting bored.

Sometimes being with your best friend is all the therapy you need. Siddhant was happy; he had forgotten about everything that Karishma had done to him in the past. All that he knew was he loved Karishma unconditionally and that he wanted to ignore or be blinded by her mistakes. All he wanted was to be just with her.

Every day forgetting all about his work, he started talking to her on the phone day and night. Punit even complained about his negligence towards the work, but he dodged him with his casual replies. Sitting in the home or in the studio, Siddhant could always be found on his phone talking to the girl with whom he was madly in love with.

Everything was going perfect and happy for Siddhant until one day when he called Karishma and found her number busy. He waited for a while and called her back again and found her number to be busy again. He dialled her number four or five times at an interval of an hour, and she was still busy on the phone with somebody. Siddhant started feeling conscious about what was happening. He was walking in his room impatiently to and fro. He tried calling her for the last time, and still she was busy on the call. Out of anger, he threw his phone on the bed, grabbed his packet of cigarettes, and went to his terrace. He normally used to avoid smoking in his house, but he was not in a mental state to think, so he went straight up to the roof.

He took out a stick and smoked, then another, then another and then another; he was smoking continuously with only one question in his mind: who was Karishma talking with that long?' Soon he was done with an entire packet of cigarettes, and with the last puff of his last stick, he decided he'll not call her again.

Siddhant was an emotional guy; he could feel that Karishma was doing something that he was trying to ignore. He was constantly thinking that she was talking to him, responding equally to his cheesy and flirty talks, demanding things from him but still not telling him anything about her feelings. He came back to his room and checked his phone; there was no call or any message from her yet. He threw

it back on the bed and started looking out of the window; he was angry and was broken. He wanted to take out his emotions or anger on something. He grabbed a paper and pen and started writing random things.

Seeing people crossing by,
Everybody busy in their lives.
I am sitting here, still searching for myself.
Searching for what I want.
Feeling Sad.
Still looking at people crossing by.
Why is it me?

Suddenly, he got distracted by the vibration of his mobile, which was lying on the bed. He jumped over his bed to grab his phone in hopes that it would be Karishma, but it was some unknown number.

'Hi, am I talking to Mr Siddhant?' A female voice came when he picked up the call.

'Yes, who is it?' Siddhant replied. There was anger in his voice.

'Hi! I am calling from Zee India Network. We have gone through your work and heard your compositions. We are coming up with couple of new shows and we require a composer and singer for this. We liked your work, and so we wanted to meet with you,' she told him, but he was not in a state or mood to talk about work at that moment of time.

'Please send me your details and other information in a mail as right now I am in middle of something. I'll text you my e-mail ID on the same number.' He didn't want to, but yes, he sounded very rude on the call.

'Yes, sure, thank you, and have a—' And Siddhant hung up the call before she could complete her line.

Siddhant was getting a good opportunity after struggling and great hard work, but still he couldn't show his happiness and excitement. All he was concerned about was Karishma. He wanted to divert his mind; he put on his jogging suit and shoes and went outside to run. He started running very fast and didn't want to stop. He was running to take out his anger, to take out all those thoughts that were going in his mind. After continuously running for fifteen minutes, he stopped to catch his breath. He was sweating a lot and was breathing very heavily and was all red, and after couple of minutes, he started running again. Everybody has their own way to relieve themselves from stress; some people meditate, some listen to music, some dance, some eat a lot, some stop eating, some hit the gym, and some start running. Siddhant was relieving himself of anger and stress by running rigorously and continuously.

After forty-five minutes of running, he came back to his home and went straight for a bath. He was feeling bit relaxed now; there was nothing in his mind now, and he didn't want to check his mobile. He went to the living room to watch some TV and to have something to eat.

'Karishma called, I heard your phone ringing so I went to check it, to karr layein baad-che call ohnu.' Siddhant's mother told him while giving him a bowl of *Rajma Rice.*

All the run therapy was wasted; he was back being reminded about Krisha. And he got upset again. He decided that he would not call her, and suddenly, he could hear his cell phone's ringtone from the other room. He ran to check who was calling as he was expecting Karishma's call, but it was somebody else calling.

'Where are you, busy?' Punit yelled at him.

'Nowhere!' Siddhant replied.

See, I know you are there at Khan Market, I just saw your Karishma there while I was coming back from the meeting with RPM's owner. Bhai don't mix your work and personal life.' Punit sounded irritated and pissed.

Siddhant fell quiet for a moment; his hands got cold, and he was unable to speak.

'Are you there,? Reply at least,' Punit shouted.

'No I am not there at Khan Market. I am at my home, but are you sure you saw Karishma?' Siddhant was little paranoid, and it was clearly visible in his voice.

'Yes, I am dead sure. You have talked and showed me her pictures so many times that I can recognize her among a crowd of 1,000 people. And, bhai, please divert your focus back to work rather than sticking to a girl who doesn't want to be yours. Aashima had told you. I have said so many times she is not for you, and please stop fucking up your work, this is an order.' Punit sounded irritated, and he hung up the call.

Siddhant again started thinking about Karishma; he didn't think of his work, his new venture, his friend who was also his business partner—all of it was waste. All he was concerned about was why Karishma was at Khan Market. He forgot his promise of not calling her that he made a couple of hours back and dialled her number, and it rang. Siddhant was relieved that it was not busy, but she disconnected the call. Siddhant was furious now and decided to send Karishma a text message.

```
 Sid                        Hutch

 Where are you Krisha? You
 called me and now not
 picking?

          Options
```

Siddhant kept on waiting for her reply, and after fifteen minutes, he received a reply from her.

```
 Krisha                     Hutch

 With mom, doing some
 cleaning work at home, talk
 to you later.

          Options
```

Siddhant was thinking why was Karishma lying to him that she was at home. Siddhant was now clear that she was with somebody and that was why she was ignoring him. And out of anger, he texted her back.

```
 Sid                        Hutch

 I know where you are. At
 least have some audacity to
 tell truth to your childhood
 friend.

          Options
```

Siddhant wanted to talk to Aashima, but it was not possible for him as she was out on her honeymoon; and second, she was married now. He didn't want to disturb her with all his thoughts and feelings for Karishma, plus Aashima had already warned him about Karishma, and he didn't want to hurt her by showing her his broken state. He wanted to take out his feelings and wanted to share what he was feeling to somebody, so he decided to drop a mail to Emma.

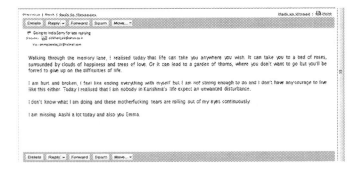

Chapter 19

He is smiling, I am Melting

It had been more than a week since Siddhant and Karishma had not talked to each other. Karishma was not bothered by this as she was busy with Rajat. She was talking to him day and night, was going on coffee dates after her office with him, going out for lunch or dinner on most of the weekends. She was enjoying her life, and she loved spending time with him.

On one of their weekend lunches, they went out to Golden Dragon restaurant at Panchsheel. It was Rajat's pick as he wanted to try some authentic Chinese food, and Karishma was all excited to go with him. Both were happy together; Rajat was praising her, cuddling her, and she was enjoying whatever he was saying and doing. Karishma placed an order for both of them, which included red Thai chicken curry, Golden Dragon's potato nest with steamed rice. She didn't ask Rajat what he wanted to have or what he liked. She imposed her presumptions on him by saying, 'Do you like Thai Curry, I have heard its worth trying, so lets order that only. We have to try it'. Food was good, ambience

was good, and they were enjoying each other's company. Rajat was flirting with her, and she was reciprocating and was touching his legs under the table with her bare feet. After the bill payment, Rajat wanted to use the restroom, so he went, leaving his phone on the table. The phone vibrated, and Karishma picked up the phone to check who it was.

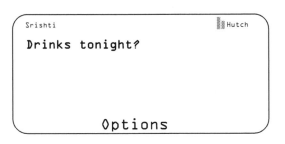

The message was from Srishti, she was Rajat's ex-girlfriend. Karishma knew about her as Rajat had told her about his past relationships.

Karishma was little surprised to see that he still have his ex-girlfriend's phone number saved in his contact list and he never told her that they are still in talking terms. And after reading the message, she was shocked that why she was inviting Rajat out for drinks. As per Karishma's knowledge, Srishti was taking some courses from Graphics Era University in Dehradun. 'So when did she come back and why the hell she's calling Rajat out for drinks and why didn't Rajat tell me about her?' Suddenly, the beautiful lunch had turned into a mystery with so many questions in her mind.

'Shall we move? I am done,' Rajat asked after coming out of the restroom.

'What is this, Rajat? Why is she texting you?' Karishma asked him with a little anger in her voice. She was holding

his phone high and was showing him the message that Srishti just texted him. She wanted an explanation from him and was expecting that.

'What the fuck is this? Why did you read my messages? This is not acceptable. I want some privacy, and I'll be glad if you give me some,' he shouted back at her and snatched his phone out of her hands. He was on the top of his temper and Karishma was looking at him totally confused. She thought, *At this moment he is the one who is wrong and so she should be the one behaving rude and angry, not him.* 'I need some explanations, Mr Rajat.' She tried to be firm and asked again.

'Please don't piss me off more as you have already contributed a lot. I am leaving; I've to go Okhla to get a part for our machine, so bye.' He stood up and left, leaving Karishma behind, sitting there wondering that what really happened. She stayed seated for some time in the same position and was trying to understand what her mistake was.

She took a cab from Panchsheel to Miyawali Nagar. She wanted to go home. The entire way she was thinking about what had happened just now. She was asking the same question again and again, 'Who was wrong?' She was unable to realise that Rajat was too smart to handle the situation and put the entire blame on her.

She reached her home and went straight to her room. She lay down on the bed, still occupied with all these thoughts. She was recalling everything that happened at the restaurant again and again in her mind. She was checking her phone time and again, waiting for a call or at least a text message from Rajat, but he didn't send her any text. And finally, Karishma decided to message him as she was getting very impatient and she wanted to clarify things.

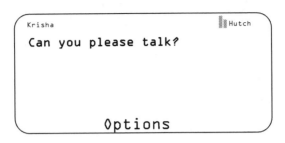

She texted him in hope that he would realise that it was him who behaved rudely and wrongly, and it was not her mistake. She thought he'll talk to her normally and would say at least a sorry for leaving her alone in the restaurant, out of love. And soon she received a message from him.

Karishma was not expecting something like that. She was stunned and baffled. 'What is this?' she questioned herself. She was feeling broken and frustrated. She wanted to yell out her anger but couldn't. She sat on the floor, threw her phone on the bed.

After constant thinking for about an hour, she grabbed her phone, wiped off her tears and decided to call Aashima. She wanted to share everything with her and dialled her number.

'You remember me? How are you, Mam? How can i help you today?' Aashima immediately said after picking up

the call. Aashima has received the last call from Karishma at the time she was at the airport and was leaving for her honeymoon, just to bid goodbye.

'Aashi, I want to talk about Rajat.' Karishma was sobbing, and her voice was choking. She told her everything that happened in the last couple of days, her lovey dovey moments and dates with Rajat. and the entire story of that lunch, of how he reacted and talked to her. 'Yaar, I don't know who is wrong. Did I do something wrong?' she further asked Aashima.

'See, Karishma, you did nothing wrong firstly, he would have done the same thing if he would have been at your place, and secondly, even if you are wrong in peeping into his phone and intruding his privacy, that doesn't make him right in the other part.' Aashima tried her best to make Karishma understand her point.

'Hmmm, Okay! But what if he has some good reason, it will be wrong on my part then?' Karishma replied after listening to her best friend.

Aashima was flabbergasted after hearing Karishma's reply. *How can she think like this? Why does she always tries to prove other person right when she knows that that person is wrong?* she thought, and before she could say anything, Karishma interrupted her.

'You know, I called Mahima while I was on my way back to home from Panchsheel. She told me that I am overthinking and overreacting. She has just asked him out for drinks,' Karishma said in a very convincing tone.

'Maybe, Krisha, what you are thinking might be right,' Aashima replied with the answer which Karishma wanted to hear. Aashima was fuming. Karishma wanted to convince Aashima that he was wrong and she was right at first and

after a while she started contradicting herself. Aashima was hopping mad now. She was cursing herself at why she took call. She could have done something apart from this because at the end of the day, Karishma will do what she feels what is right for her, no matter what Aashima tells her or explains her.

'Krisha listen, I've to hang up now. My mother-in-law is calling me. She has invited few guests, so I've to attend to them. You please take care, okay? I'll call you later.' Aashima bid her goodbye, and she had a sigh of relief the moment she hang up the call. She sat down on her bed and started thinking about Karishma. She was worried for her childhood friend as Karishma was not making right decisions in her life. Aashima wanted to help her, but she was helpless and could not do anything about it.

Aashima thought of calling up Siddhant. She wanted to talk to him as he never showed up or called her since the day she left for her honeymoon. It hasn't happened ever that he was completely out of touch since that long. She dialled her number to talk to him.

'Oye,? How are you?' Aashima asked Siddhant the moment he picked up the call.

'I am good, Aashi, how are you and Palash? How was your trip?' Siddhant asked.

'Everything is good. I'll be posting the trip pictures over Orkut soon. You tell me where are you? No call, no text, nothing.' Aashima asked him again.

'Nowhere, Aashi, I am just here. I'll surely check the pictures. So, what's new?' Siddhant replied very abruptly.

'What's bothering you, Sid? What happened? You are sounding down. Why are you so quiet?' Aashima asked him in her worried tone. Siddhant didn't reply; he was quiet.

Aashima checked her phone to see whether the call is still connected or not, and she asked again, 'Sid, what happened? I am worried now. Speak up, tell me what is bothering you?'

That was the breaking point for Siddhant. He started telling her what all happened between him and Karishma. Aashima could easily figure out that he was very upset.

'Dude! I warned you, so many times,' Aashima said with a bit of anger in her tone. She was thinking about why was he behaving like that as she had already warned him about everything, but still he didn't listen to her.

'I know I was a fool, Aashi, I know,' Siddhant replied.

'Listen, I don't want to explain anything to you right now because sometimes people learn from their mistakes, and I hope you might also learn a lesson from your mistake now, and I hope you'll never repeat your mistake now. I think you have got the right message,' Aashima told Siddhant.

'Yes, I wish I could have understood when you were warning me and telling me what was right and wrong for me, but I was overpowered by my love and feelings so much so that I was unable to differentiate between black and grey,' Siddhant replied with sadness in his tone.

'Chill and relax, we are always there for you. Chall, I have to go now. I will make plans to meet soon. Take care and keep smiling,' she said and they hung up the call.

A couple of days passed, and Karishma was trying to forget the incident between her and Rajat that took place at Golden Dragon. She was not talking to him, or shall we say she stopped calling him after attempting to call him thirty to forty times and dropping fifty to sixty text messages without a single reply from his end. She was trying to divert her mind from Rajat in every possible way she could. She was keeping herself occupied with her office work most of

the time, and whenever she gets a free time or wanted to take her stress out, she scrolled over her friends' profiles and their pictures on over Orkut.

It was one of the regular days at her office while she was doing her work. After banging her head with numbers and figures for about two to three hours, she logged into her Orkut account. She went to her scrapbook to check if she has received any messages. There were couple of scraps from her college friends; she replied to them. She was smiling after seeing and replying to her friend's funny scraps. Afterwards, she started scrolling pictures of her friends who were there on her friends list. She came to the name Rajat, and she thought of just peeping into his pictures. Although she was not talking to him, she was very much interested in what was going on in his life. She opened his scrapbook to check his messages; the one disadvantage of Orkut was the open scrapbook that anybody could see scraps from everybody. She didn't find anything mischievous. She then opened his photo gallery and saw an album named 'Club Eelevates Night Fun' was there, which was created just a few hours earlier. She opened that album and started scrolling down the pictures, and suddenly she was stuck on a particular picture: It was Rajat and Srishti's imitate picture, and Karishma got furious on seeing that picture. She lost her temper and grabbed her phone to call him. She called him, and he disconnected. She called him again, and he disconnected—it continued for about five to seven minutes, and soon his phone was switched off.

Karishma wanted to talk to somebody, but she didn't know with whom. Aashima was now busy in her married life; she cannot call her all the time. The next name came in her mind was Siddhant's. But she knew that she had behaved

badly with him and it would be very difficult to explain him about everything at that point of time.

She went back to her computer and started looking at the picture again. She was checking each and every picture of Srishti very minutely and started wondering if was she hotter and prettier than her or not. She was so much stressed and was burdened by her thoughts that she finally decided to call Siddhant and dialled his number.

'Hey, Krisha, all well?' Siddhant picked up the call immediately after seeing Karishma's number flashing on his mobile screen. It was after so many days they were talking to each other, and Siddhant was so desperate to talk to her.

'I am fine, how are you?' she asked him in a low tone

'Forget about me, what happened to you? Why are you sounding so low?' Siddhant showed his concern for her.

'No, everything is fine, it's just workload I guess, nothing else,' Karishma replied.

'Okay,' Siddhant said. He knew she was hiding something from him, but he didn't want to ask her again as only thing he was concerned now was that Karishma was sad and he wanted to cheer her up. He started talking to her about other topics; he was telling her funny jokes and incidences, and in short he was trying to heal her pangs. Karishma was giggling and was laughing over his jokes, but he could figure out that she was faking it; he could feel that she was not listening or taking interest in his talks and was just laughing out for his sake.

If she didn't wanted to talk, then why did she call? Siddhant was asking this question to himself again and again in his head as she was not showing her interest and was not putting efforts in their conversation. But for Karishma, that was really necessary as for her, calling somebody when she is

stressed is like a stress buster. She'll not talk much, she'll not contribute words in the talks, but still she'll call somebody just to be rid of her restlessness. at.

'Krisha, you remember our school days and old times? We used to have so much fun all together.' Siddhant gave another try to bring her back into the conversation.

'Hmm! Yes, it was a good time. I miss those days.' Karishma replied and her tone showed that she was not interested in speaking up.

Siddhant gave three or four more attempts, but he was not getting proper replies from Karishma, and finally, he was done with her and said, 'Krisha, Punit is calling me. We have a recording session, so I'll get back to you the moment we'll get done with that.' And he hung up the call. Karishma didn't even ask him to stay; on the contrary, she just said bye.

Karishma came back to her house after the hectic day at work and was sitting in her room with her own mental pressure. She was not in a mood to sit with her family or to talk to anybody else; all she wanted was to talk to Rajat. She tried calling his mobile number a couple of more times, but she found it to be still switched off. She had never ever thought that something like this would happen between her and Rajat. She was sad and didn't take her supper that night. She didn't realise what time she fell asleep as she was lost deeply with Rajat in her thoughts.

She woke up in the morning, and the very first thing she did was check her mobile phone in hopes of Rajat's call or message, and yes there was a message from him which he had sent in the night.

```
┌─────────────────────────────────────┐
│ Rajat                      ▓▓ Hutch  │
│  Sorry, I was angry at you.          │
│  Call me whenever you get            │
│  time....                            │
│                                      │
│              Options                 │
└─────────────────────────────────────┘
```

Karishma immediately got up and dialled his number; she was so desperate to talk to him.

'Hey! Morning!' Karishma greeted when he picks up the call.

'Hi, good morning! How are you?' Rajat asked in a bit sleepy tone.

'Just fine, you?' Karishma asked.

'Yeah, I am fine, just a little headache due to hangover I guess,' he replied.

'Hmmm.' Karishma made a sound.

'So how was your office yesterday?' Rajat asked.

'It was okay,' she replied.

Both of them kept asking such questions and giving each other one-word or one-liner answers; this continued for a while, and then Karishma couldn't resist herself, and she asked him about the picture that she saw in his Orkut account.

'I saw your pictures from Elevates,' Aashima said.

'Ya, so?' he replied in a very rude tone.

'Why were you so intimate with Srishti?' she asked him.

'Why the hell are you having problem?' he replied in the same rude tone just the pitch was on higher side this time.

Karishma was shocked to hear this; she never expected that he would react and reply like that. She recalled an

incident when Siddhant wrote a testimonial for her on Orkut profile, which he ended up with the line, 'Thanks for being my friend, love you.'

Rajat created a whole scene out of that, he got so much against Siddhant at that moment that he asked Karishma to delete him from her friends list. Rajat even fought with her on seeing couple of pictures of her and Siddhant, which Siddhant had posted on his account. He didn't like the picture, and the reason that he gave was that Siddhant's arm was over Karishma's shoulder. And according to him, friends don't pose like that. So that picture was offensive for him, and when Karishma tried to explain to him that there was nothing to be offended with the picture as there was nothing between her and Siddhant, and both of them are just best of friends, Rajat yelled at her and ordered her to do what he has asked her to do. Tables have turned now; it was Rajat who had an offensive picture of him with his ex-girlfriend posted on a public domain, and Karishma wanted to tell him that it was not acceptable.

'I didn't like your picture with Srishti in which you were holding her. She is your ex—' Karishma was telling Rajat about how she was feeling, but she got interrupted by him.

'What are you trying to say, Karishma? Don't you trust me? 'Rajat yelled at her and hung up the call out of his anger. Karishma was back into her thinking loop and started wondering who was right and who was wrong.

She got ready and went to her office, still lost in Rajat's thought. She was asking herself again and again, 'Why is he behaving like this?' She was thinking about the morning incident and was feeling sad about it. But the day was not over yet; she received a message form Rajat during her lunch hour, and she was shattered when she read that.

```
 Rajat                          ▓ Hutch
 I am leaving for Jaisalmer
 today with Srishti and gang.
 We'll talk when I'll be
 back. TC

            Options
```

Karishma was unable to concentrate on her work because of her feelings that were about to burst.

'Karishma, are you fine? Everything okay? I am noticing you since the morning and you look disturbed, what happened?' Poonam, Karishma's colleague asked her. She was an altogether different person who is expected to ask the most weirdest questions.

'Nothing, yaar, I am just pissed off with my life' Karishma said and narrated to Poonam the entire story. Karishma was expecting positive suggestions from a wrong person.

'Leave him. Seriously, leave him, girl. What are you doing with your life? Why are you taking his shit again and again? We are not meant to be like this. No one can tell us we have to do, You stand for Woman Empowerment.' Poonam replied in a very bold tone.

'Hmm!' Karishma was listening to her carefully and was agreeing on whatever Poonam was saying or telling her unless she talked about the woman empowerment thing. she gave her a stare. she went too far from the topic.

After getting done with her office, Karishma thought of calling Aashima. She took a cab from Naraina and dialled her number.

'Hello, Aashi! I've decided what I want to do now,' Karishma said without waiting for Aashima to even say a hello.

Aashima got worried after listening to Karishma; whenever Karishma has taken a decision, Aashima had paid for her decisions every time.

'I will dump Rajat. I don't feel like talking to him anymore. I talked to a friend in the office, and she made me understand that I was acting stupid. He doesn't deserve me.' Karishma completed her words.

Aashima was amazed after hearing such words from her best friend. She understood the thing from a random office girl which Aashima was trying to explain to her from so long. But she was glad that whoever it is, she is now thinking on the right path which was most important.

'What do you think, Aashi?' Karishma asked.

'Yes, you are making a wise decision, Krisha, but just stay stuck to your decision now,' Aashima said.

'So should I call him to tell this? Oh no, not on call, he'll overpower me in words. Let me message him and tell him not to call me now, or should I wait for him to message me first? Or shall I just start ignoring him now like he is ignoring me? I am very much confused, yaar. Help me out, Aashi. What do you think? What would be right?' Karishma fired so many questions at once at Aashima.

Aashima was wondering why she was even asking her about what she should do when she knows that she'll do whatever she'll feel was right for her.

'Aashi, tell me na. How's the idea?' Karishma brought Aashima out of her thoughts.

'Great! You are all set, just do it now. Catch you later now. All the Best' Aashima said and they both hanged up the call.

Karishma was thinking about her plan and got stuck on few things, so she decided to call Aashima back. 'Aashi, what if he'll say sorry and apologise for his behaviour?' she asked her.

'See, Krisha, "sorry" is like a weapon used by people who do mistakes without realising how big it is.' Aashima tried to make her understand a point.

'Ya, you are right, but what if he genuinely feels sorry and apologise?' Karishma was not convinced with her point and asked her again.

'And how will you figure out that his feelings are genuine or not?' Aashima asked her and sounded bit irritated, which Karishma understood. She thanked her and they hung up the call.

Karishma was clear in her mind that she'll not call or text him anymore, and the same happened—she didn't call or message him even when he was back from his Jaisalmer trip. Until one day when Rajat finally called her.

'Hey, Krisha, I am sorry for overreacting like that day.' The very first thing that Rajat said the moment Karishma picked up the call.

'It's okay,' Karishma replied in a very casual tone that said she was not bothered anymore and that he was nobody in her life.

'So, let's meet up in a day or two, whenever it suits you,' Rajat asked her.

'No, I am little busy with my office these days, will be leaving for Hyderabad in next two or three days for a corporate event.' She maintained her pitch.

'Oh, okay! We'll catch up when you get back then. Bye,' Rajat said and they disconnected the call.

The ICICI Bank was having their three–day-long annual corporate event in Hyderabad. Employees from all the branches in India were coming there to represent their branch, and Karishma's manager has asked her and Poonam to come along him to represent their branch. The entire week, she was busy in making a PowerPoint presentation that her boss had asked her to prepare, with bank's business data and other details that are to be included. Apart from making a presentation, she was busy shopping, tailor visits, and packing.

* * * * * **Hyderabad, the Life-Changing Place** * * * * *

After landing at Rajiv Gandhi International Airport, Karishma, and colleagues went to ITC Kakatiya hotel in a cab, which was arranged by her company. It was very beautiful hotel with a big swimming pool, lush green gardens, the beautiful antique décor, beautifully carved in white marble. It was like a small paradise. They reached Hyderabad in afternoon, and after resting for a while, Karishma started getting ready for her presentation in the evening, followed by drinks and dinner later in the night.

The presentation went well, and everybody seemed impressed. The hotel staff had arranged the dinner in their ballroom, so Karishma was there with Poonam. Both of them were talking to each other with a glass of wine in their hands when a guy came up to them.

'Hi! It was a really good presentation,' the guy said in his bold manly voice.

'Well, thank you.' Karishma gave a puzzled smile as she didn't know who that guy was.

'Gaurav Luthra, manager at GK branch.' He extended his hand.

'Oh! It's nice meeting you, Gaurav, I am Karishma and this is my friend, Poonam, we work at Naraina branch,' she replied him and extended her hand.

Karishma was impressed by the way he introduced himself and the way he was talking to her. Although he was not that good-looking, he had a smart personality. Tall, around six feet one, six feet two, lean body, bold voice, superb dressing sense, and the way he was talking—he was a complete gentleman.

They started talking to each other while walking around all over the event. Both of them were taking interest in each other's talks and life. He told her that previously he was working at American Express, and listening to that, she got more impressed with him. Gaurav was blown over by Karishma's smile, her pretty face, and her confident way of talking—he was mesmerised by her. After dinner and couple of drinks together, Gaurav took his leave as he had to prepare his presentation, which he had to present the next day.

'Karishma, will you join me for a cup of coffee tomorrow after presentation?' Gaurav called her from behind, while she was walking back to her room.

'Yes sure, why not!' Karishma replied with her smile.

'And one more thing, thank you for this wonderful evening,' he called out again. Karishma was blushing and was smiling. There was no Rajat, no Siddhant, no Aashima in her mind at that moment; she was only thinking about Gaurav now, his voice was echoing into her ears and giving her tingles.

'Wow! How could you talk to a strange person that comfortably, Karishma? It's so easy for you,' Poonam asked her while lying on the bed.

'It's my nature! I love knowing new people. I love to know about their life, so that is why I don't feel shy talking to any stranger,' Karishma replied while yawning, and they went to sleep.

The presentations were going on for the past three to four hours. Karishma was looking at her watch again and again. She was eagerly waiting for the presentations to be over and she could go out for coffee with Gaurav. She had no interest in what was going on in the presentations. She was lost in her thoughts.

'Next, I would like to invite Mr Gaurav Luthra, manager from our GK, New Delhi, branch.' The announcer calls Gaurav's name; it was his turn to get on the stage and give the presentation.

Karishma got attentive the moment she heard Gaurav's name. She saw him going up the stage; he was looking very handsome and professional in his three-piece wine colour Italian suit with black shirt under the coat. Karishma's eyes were glued on him. He started giving his presentation; he was constantly looking at Karishma who was sitting on a table in the second row from front and was smiling at her. He was telling about the facts and figures of his branch in his bold voice. Karishma was lost in his voice, no matter what he was saying or telling about his branch's business.

The presentations continued for another half an hour after Gaurav's, and then it was finally over. Gaurav came to Karishma and asked her to get ready and meet him in the hotel lobby after fifteen minutes. She bolted to her room to get ready; she didn't want to give him any bad impression

of herself. She put on a orange-coloured dress with the matching bellies that Siddhant sent for her. She put on light makeup with a light orange-shade lipstick, and within fifteen minutes, she was in the hotel lobby where she saw Gaurav siting on the couch with a magazine in his hands.

'Good to go?' Karishma asked him in her bubbly tone and drew his attention towards her from the magazine.

'Wow! I am impressed. You are on time,' he said and stood up while placing the magazine back on the table.

They went out of the hotel where a cab, a luxurious cab, was waiting for them; they sat in the cab, and Gaurav asked the driver to move. Gaurav has not disclosed the place where he was taking her for coffee, and soon the cab stopped.

Gaurav had taken her to Adaa Coffee Shop at Taj Falaknuma. Karishma was totally mesmerised by his efforts. Each and everything about that place was grand. She was feeling like a princess. She could actually imagine herself wearing a crown on her head. He was treating her indeed like a princess. He pulled a chair for her and sat after she got seated.

They ordered their special coffee, which was served to them in a royal manner. Karishma could witness royal rituals that are fit for kings and queens. Both Karishma and Gaurav talked to each other about their likes and dislikes, hobbies, and they were enjoying each other's company. The coffee date finally ended and soon they were back at their hotel. Karishma could feel she had the slice of heaven. It was the best experience she ever had.

'Thank you for a wonderful evening, Gaurav, it was really special, and I'll never forget this one.' Karishma thanked him.

'My pleasure, dear, go to your room now, you must be tired. I'll catch you at breakfast tomorrow.' He waved at her and took his leave.

They spent the last day at Hyderabad together; he again arranged a luxurious cab for sightseeing and shopping. She was impressed with his efforts that he had put for her. While coming back to Delhi, they were in the same flight, and throughout the flight both of them sat together, talking and teasing each other.

They bid goodbye to each other while exiting the airport and exchanged their phone numbers. She reached her home, and the moment she entered her room she received a text from him, asking her if she has reached her home. She was touched with his gesture of caring and showing concern towards her, and from that day onwards, they were in constant touch with each other via calls and messages.

Karishma went back her office and was burdened with lots of pending work at her table. Her clients were eating her head; her boss was nagging her to finish off the pending work quickly, and she was busy in acquiring new customers. He was calling and dropping her messages, which Karishma was ignoring totally. She didn't want to talk to him anymore as what he did to her was not right. After a busy schedule, she was finally about to finish the agenda for the day when her mobile vibrated. It was a text message from Gaurav.

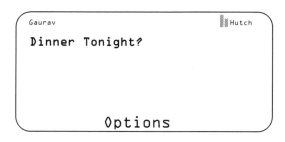

Gaurav　Hutch

Dinner Tonight?

Options

Karishma got excited after reading that message; there was a smile on her face. For an instant, she forgot about her work and office.

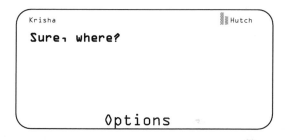

Krisha　Hutch

Sure, where?

Options

She waited for his reply eagerly.

Gaurav　Hutch

At my place, my parents are out of town and I've special plans for you. My driver will pick you up by 6:00.

Options

Karishma was not expecting something like that. Now she was excited and bit of nervous. She was not sure, and she was questioning herself 'should I go or not?'. To decide

the same, she went into the washroom to have look at what she was wearing. Her outfit was okay, an olive coloured shirt with black skirt. She canned herself for another five minutes and came to the conclusion that though she is not looking fat but the outfit is ok.

"I am not sure i can go in these clothes or not" and she came back to her desk and wrote a message to him.

```
 Krisha                          ▓ Hutch
 FROM THE OFFICE? No, I am
 not well dressed.

            Options
```

Karishma texted him and he glued her eyes on the mobile's screen, waiting for his reply.

```
 Gaurav                          ▓ Hutch
 I am sure you'll be looking
 pretty. You don't have to
 worry; I don't judge people
 with their clothes. Be ready
 by 6:00. Bye!
            Options
```

After spending the entire day in the office, with eyes on the watch and excitement in the heart, Karishma was all set to leave her office for her dinner date with Gaurav at his place. It was finally 5:50 p.m. on the clock when a white -dressed man entered into the bank and asked for Karishma.

'Madam, wo gadhi aagai hai, Gaurav saab ne bheja hai.' The white-dressed guy told Karishma. He was Gaurav's driver. She asked him to wait outside and told him that she'll be there in couple of minutes.

She quickly went to the washroom and took out all the things she could find in her bag that can make her look better. She fixed her hair (at least two to three times), put on lip gloss, some perfume and Kajal in her eyes. Then, she gazed at herself for couple of minutes and yes she was good to go. She went outside her office to look for the car, and what she saw next was breathtaking.

There was black-coloured shiny Mercedes with a red light on the roof by the office's gate, with the driver standing beside it. The driver opened the car's door, and Karishma hopped into the car. She was all happy and amused with the VIP treatment that she was getting.

'Bhaiya kahan jaare hai hum?' Karishma asked the driver as she wanted to know where they were going.

'Chatarpur, madam, sahib ka ghar wahan hai.' The driver replied, and she raised her eyebrows after hearing Chatarpur as it is one of the posh and expensive places to have a house.

'Ye lal batti kyun hai oopar?' she enquired him about the VIP red light on car's roof.

'Badhe saab ka bahut naam hai neta wagera me, VIP hai hmare saab.' He told Karishma about Gaurav's father. He was a very big industrialist and had many political contacts. She was more impressed after knowing about Gaurav's family background. She enquired him more about Gaurav's family and everything, which driver told her on their way.

After a ride of one and a half hour, finally they were there in front of a big gate with 'LUTHRA'S' written on a golden chrome name plate. Karishma was flabbergasted with the view, which she saw the moment she entered that big gate. There was a path going towards a white-coloured big house with grass lawns on both the sides of the path. She was amazed and stunned as she has never seen such a house in her life ever. The driver dropped her at the door of that magnificent house.

'Hello, beautiful,' Gaurav greeted Karishma. He was standing at the door to welcome her. He was very casually dressed in a white T-shirt, light blue jeans with a casual checked blazer over it.

'Hi! How are you?' Karishma replied and fumbled a bit. Gaurav's bold voice gave her goose bumps. She moved forward and both of them gave a hug to each other.

'Nice Perfume Karishma,' Gaurav complimented her.

'Well, thank you' Karishma blushed and replied. She was so happy.

Gaurav took her inside his house, which was like a palace from inside. She was amazed to see the living hall of his house; it was very big area, with expensive ethnic furniture, decorated with great antiques, family portraits hanging on the walls, and a big chandelier in the centre of the roof that was lighted up, and the entire house was all illuminated with its light.

'Let's go upstairs, I've done special arrangement for dinner over there,' Gaurav said, bringing back Karishma from her thoughts, and she started walking up the stairs behind him.

He took her to a room with a beautiful wooden table placed beside a glass window from where one can have an

entire view of the beautiful lawns and trees all around that beautiful house. The interior of that room was all wooden with more antiques to decorate the room. She kept on moving silently, and she was sweeping that room with her amused eyes.

'Please have a seat,' Gaurav said and pulled a chair for her.

'Wow, this is so amazing,' Karishma said after looking at the arrangements that Gaurav has done for her. 'Thank you, Gaurav.,' she said with an excitement in her voice.

'Thank you, I am glad that you loved all this,' he said and smiled.

'I am totally bowled over. It's like I am in a palace to have supper with a prince. Are you a real prince?' she said and started laughing.

'Ha ha ha! No! No! It's not like that, my dad had dreamt to build a property like this, it was his dream, so when our business got established, the first thing he did was this house,' Gaurav told her.

'Yeah, your driver told me about your business. Can I ask you why are you working at a bank?' Karishma enquired with him very enthusiastically.

'See, this house, all these luxuries and everything, my father earned it with his hard work. This is his hard work. I want to do something myself also. It will take lot of time though, to make something similar, but I want to do something valuable on my own. So, here I am, working at a bank at a good position, with all my hard work and dedication. When I'll think time is right, I'll join my family's business,' he explained to her everything, and she was listening to him quietly.

'Wow! You are quite an inspiration. I have seen situations like this only in movies,' she said.

'My dear, the things that are shown in movies are somewhere inspired from real lives only. He replied. Gaurav called one of his servants and asked him to serve the dinner.

There were no drinks on, but still Karishma was high—high in Gaurav's company. They were talking about each other's lives, about their goals, their families, few office-related talks, and everything else.

'I guess I should leave now,' Karishma told him while looking at her watch.

'Yeah, it's quite late, even I didn't realise that. I was lost in your talks, I guess,' he said with a smile. Yes he flirted, but it didn't sound cliché.

Both of them stood up and started heading towards the main door. He grabbed the car keys and guided her to his car.

'Are you dropping me off?' she asked Gaurav.

'Yes. Why, you don't want me to? Ha ha ha,' he countered and started laughing.

'No, I mean it's not like this. I was thinking that your driver would be dropping me off,' she said while getting into the car.

'I sent him to pick you up as I was coming from the office and had to check the arrangements here, else I would have been your chauffeur, madam,' he said with the same smirk on his face and winked at her while switching on the engine of the car. Karishma was on seventh heaven, she was totally mesmerised with this guy who was treating her like a princess. He was taking care of everything.

They were talking to each other through their ride, and soon they reached Miyawali Nagar. He drove his car into

her street and stopped in front of her house. Karishma's dad, Mr Seth, was standing in the veranda and was waiting for Karishma. Karishma told that him that her dad was standing at the gate.

'Oh, let me meet him,' he said to Karishma, and they both get off from the car.

'Papa, this is Gaurav. He is the manager of our Greater Kailash branch.' Karishma introduced Gaurav to her father.

'Hello, Mr Seth. How are you?' Gaurav greeted her father not like her other friends who greet his parents with namaste and feet touching; he greeted him very professionally and boldly.

'Hello, beta. I am good.' Mr Seth's replied

Come, have a cup of coffee or tea.' Mr Seth further invited Gaurav.

'No, sir, please no need of formalities. I just came to drop Karishma as it was quite late, and I didn't want to disturb you all at this hour of night. I'll surely come one day, thanks. I must take your leave now. Good night.' He greeted both of them and went back to his car while Karishma was waving her hand while bidding goodbye.

'He is a nice guy, with etiquettes' Mr Seth said while moving inside the house with Karishma.

'Yes, indeed,' Karishma replied very casually, though she was feeling excited.

Karishma went to her room and lay down on her bed, without even changing her clothes, and started thinking about the beautiful time that she had spent with Gaurav. She started thinking, *He is such a nice guy, and despite belonging to such a well-off family, he is so down to earth and hardworking. He praises me, and I adore his company as well. I think he is the right guy for me. Even Papa liked that guy. I*

think we will have a future together.' With all these thoughts running in her head, soon she fell asleep.

Soon they started meeting each other more often over coffee and dinner. He took her to various good and expensive restaurants and coffee houses, which impressed her a lot, going out on movies and started talking to each other on the phone for hours. And soon both of them realised that both of them are in love. They expressed their feelings to each other, and both of them were so happy on knowing that both of them felt the same way for each other. Both of them wanted to spend their entire life with each other and wanted to tie the knot of togetherness. Gaurav's parents were aware of Karishma; they knew that their son liked her and he wanted to get settled with her. Although they wanted to marry their son with someone from affluential background but sill they were not saying anything to him. Probably they were waiting for the right time or maybe not. Karishma's dad had a hint from the first day he met Gaurav, but he was not sure until the day when Karishma's mother told him. Karishma told her mother about her feelings towards Gaurav and asked her to talk to her father.

'Your mother told me that you like Gaurav and want to marry him, is that true?' Mr Seth asked his daughter.

'Yes, Papa,' Karishma replied and sounded bit scared.

'Then why didn't you tell your papa about it. I know throughout your life, I've imposed restrictions on you, but it was my possessiveness towards you, my princess. I liked your choice. Gaurav is a decent guy, and he'll always keep you happy,' Mr Seth said with his hand over Karishma's head. The strict father melted in his love for his daughter. and he agreed with his daughter's choice. Karishma hugged

her father tightly, with tears rolling over her cheeks. She was so happy.

Karishma was happy that finally she had got the type of guy like she always wanted, well settled and well-off. Most of all, her parents also approved of her decision. She was now sure that her life is going to be like a bed of roses and her future was secured now.

Chapter 20

Do More Than Just Exist

Everybody was busy in their life: Aashima with her new family and Karishma was busy with her bank and Gaurav. Then it was Siddhant, who was trying hard to take his mind off Karishma. Siddhant was working harder and harder, day and night, making and composing new songs, performing at various clubs and events. He had started building his solo career,.

With this busy life of making new songs and various activities, Siddhant received a mail form Emma while he was checking his mails in his studio one day.

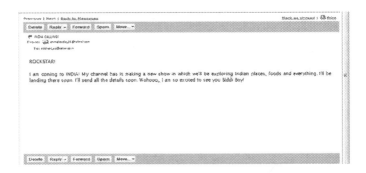

Siddhant was happy to read that mail. Emma was working hard and had gotten an offer to work with Fox History and Entertainment, and she was coming to India. Siddhant was excited that finally, he'll be meeting her after such a long time. He was lost in his thoughts about Emma.

Meanwhile, it had been two years since Aashima was married and was leading a very happy married life with such a loving husband and caring in-laws, and now a new member was coming into their family. Yes, she was expecting the baby soon but she kept it a secret from Sid and Krisha. Mostly because both of the were busy in their life's, in their schedules that they had no time to talk to each other. It was December and Palash's birthday was coming and Ashima decide to throw a big surprise party for him. She texted everybody the time, and place and requested them to be on time. Yes, she invited both her friends also. The entire house was decorated with flowers; there was a tent tied up outside their house and a caterer was preparing food.

'OH MY GOD,! You are here. How come you always make it on time?' Aashima shouted out of her excitement on seeing Siddhant after a very long time. She stood up to give him a hug.

'*Had to and* could you please stop shouting here at least. You should behave at your in-laws'.' Siddhant was amazed to see that there was not a pinch of change in her attitude; she was still the same. He gave her a hug and made her sit very carefully. Siddhant continued, 'You are still mad, Aashi, I thought you might have gained some wisdom after your marriage, but you are still a lunatic person.' And Siddhant started laughing.

'Ok, I want you to meet someone' Sid told Ashima and called out for Emma.

Ashima was startled.

'Hi! I am Emma, Sid's friend' She greeted Ashima and introduced herself politely. Ashima was not understanding exactly what was happening and she was staring at Sid. She then wished her and hugged her. Still not knowing what was happening. Sid could understand her confusion and asked Emma to excuse them for a minute and told Ashima everything. How they met, how they were talking on mails, and why has she come to India. But Ashima could see something else, something in both of their eyes. She could see the love for each other. Ashima then told Sid that she was expecting and Sid hot very happy. He congratulated her. Ashima had to attend all the guests so she took their leave and started meeting everybody else.

'Hi, baby! How are you? Congratulations!' Karishma shouted out of her excitement and hugged Aashima.

'Look who showed up finally. I am good, how are you?' Aashima sounded happy.

'I am good, it's so good to see you, Aashi. I was missing you like hell. Oh my God! The bump!' Karishma immediately could make out that she was expecting. Aashima saw Gaurav and she understood that he the 'new guy' in her life and she greeted him.

'Hi, Aashima! Congratulations!' Gaurav said.

'Thanks a lot, Gaurav, and thanks for coming,' Aashima replied.

'Hi Karishma' Sid came from behind

'Hii Sid! Long Time, How are you?' Karishma sounded excited to see him after such along time.

Siddhant introduced Emma to Karishma and Gaurav. Karishma was not comfortable when she met Emma. She was disturbed to see Siddhant with a girl. Throughout the

party she was again and again looking at both of them. She couldn't concentrate on what Gaurav is talking. Gaurav was also bit worried looking at her behaviour as she had never behaved the way she was behaving that day.

"HAPPY BIRTHDAY!!!" everybody shouted and cheered when Palash entered. He was surprised to see everybody. They all enjoyed the evening, dancing, and having a gala time together. Only one person in the whole party was not enjoying and that person was Karishma. She was probably not comfortable with idea of Siddhant being with a beautiful girl.

Anyhow the party ended and they all went back. That night Karishma was so restless that she decided to call Siddhant.

'Hello' Emma picked up his phone and answered it.

Karishma immediately disconnected it. She started talking to herself that why is she being jealous to see Sid with another girl.

She couldn't sleep. She woke up in middle of the night and saw the time, it was 4'O clock.

'Krisha you have to go to work tomorrow. Why are you spoiling your sleep' She was constantly telling this to herself and trying to sleep. It was a hard night for her. She barely slept. In the morning she was too sleepy to go to work and she decided to take an off.

She wanted to know more about this girl, Emma and Ashima was the correct person.

'Hi Ashi, what's up? wanted to talk to you' Krisha immediately spoke when ash picked up.

'Hi Krisha, so early in the morning. Everything fine?' It was seven in the morning and she got little surprised.

'Who is this girl Emma? never heard about her before. Is Sid dating her?' Krisha was full of questions.

'No Not exactly dating in present but I can see it in their eyes. They are a made for each other couple. They look so adorable together.

Krisha although did not like what Ashi told but still she had more questions to ask.

'When did they meet?' Krisha again promptly asked

'They met on their Paris Trip' Ashima told her.

'Why do you ask these questions early in the morning Krisha. What happened?' Ashima feelt strange so she asked her.

'No. Nothing, Nothing at all. I will call you back in sometime. Bye' Karishma quickly said and disconnected the phone.

Aashima still couldn't understand what was happening to Karishma.

Meanwhile, Gaurav called up Karishma

'Hi Krisha, Are you fine now? Yesterday you were behaving very weird' Gaurav asked krishna in a concerned tone.

'Oh yes, yes I am Gaurav. Just bit tired. Didn't go to work as well. I will be fine, don't you worry' Karishma immediately covered her behaviour by an excuse.

'Oh ok, you take complete rest. And if you need anything do let me know'. Gaurav still was very concerned for her.

'Yes Gaurav, trust me, I will be fine. Don't you you worry' Karishma wanted Gaurav to relax and not take any tension.

'Just take care of yourself' Gaurav then disconnected the phone.

Karishma kept on sitting in the same posture for long struck at thinking about Sid and Emma. She wanted to stop thinking about her but couldn't. She was angry on herself. She went to the mirror and started talking to herself.

'What are you doing? Why do you even care about Sid? He is a closed chapter of your life. You have the best boy in town and instead of being with him you are thinking about Sid? Why? You have got what you always wanted. Stop it now'. After few minutes of self talk, she thought she was fine now and she started diverting her mind thinking about time spent with Gaurav.

Karishma in the evening got a call from her manager that she has to go for three months training to Bangalore the very next day. She will be getting accommodation from office only. Karishma thought probably this will take her away from the thoughts of Sid and she will be fine there. She started packing as she had to leave early in the morning. She had a lot of work, so she just dropped a message to Gaurav that she has to leave tomorrow morning for Bangalore.

The next morning she left for the airport with her parents who were dropping her. On the way she tried calling Gaurav as she was too busy to talk earlier but he disconnected her phone with an automated message in which it was written "I am in a meeting. Will call you later". Karishma was bit upset because she couldn't talk to Gaurav.

She landed at Bangalore airport, she took her luggage and went out to search for a taxi. She saw a very familiar guy standing there with bunch of roses. She couldn't make out who is he as he was at a distance. Soon he came forward and Karishma almost jumped when she saw him. Yes, it was Gaurav standing there and waiting for her.

"Oh my God! Now I never expected this" and she hugged him.

'Such a nice surprise it is, I love you' and Krisha went on and on as she was very happy.

'Come lets go to our room' Gaurav told krisha.

'Our room?' she couldn't understand and sounded confused.

'Yes, my dear. I have taken a month off to be with you. And I have rented a room for us very near your working place so that you don't have problem in commuting.' Gaurav told her eagerly.

'Wow! we are going to live together. It's like a dream come true.' Karisma almost jumped off from ground.

They reached the place where Gaurav had taken a room. It was all very nice, their room was on twentieth floor with a beautiful view of the city. They had two bedrooms in the flat and one big living room with nice comfy sofa and home theatre system. It was a very well furnished flat.

'So, How is it?' Gaurav asked her

'Awesome is the word Gaurav, you have done an excellent job. Love you'. Karishma quickly hugged him again.

Gaurav asked her to wait for a second and he went towards the music system, switched it on a connected his mobile with it. he played the instrumental music of titanic song.

'Would you like to dance with me' He went on his knows and asked her.

'Of course' Krisha was too happy with his romantic gesture.

They danced off in the evening which was indeed a romantic start.

Chapter 21

A Neat Freak

The next day Karishma left early morning for work. Gaurav was sleeping at that time. When he woke up he saw tea flowing down in the kitchen, Bread packet open on the table. Everything was bit messy. He cleared all the mess which Krisha had made and then went for shower.

He got a shock of his life when he entered the washroom. On the door of the washroom, Krisha's undergarments were hanging, on the floor her dirty clothes were kept or thrown, toothpaste marks were on the floor and the carpet. Gaurav got pissed off.

He was a cleanliness freak and was allergic to all such things. It took him lot of time to clean up the mess and then call for the cleaning lady.

Krisha came in the evening and and Gaurav welcomed her politely. He asked her how her day was, who all are here etc. Then, he told her that he has got a basket for dirty clothes where she can put them.

She got little embarrassed realising that she had put everything on display in the morning.

'I am very sorry baby, will take care of it in future.' Karishma politely said to Gaurav.

'Its ok my dear, you don't have to be sorry. Just one more thing, if we will leave bread open it will accumulate dust, so be careful from next time.' Gaurav told her carefully in order not to hurt her.

Krisha for the first time felt if she is not with her boyfriend but some mother-in-law telling her to maintain hygiene. She felt awkward but didn't really show to Gaurav.

Days passed and Karishma now was utterly conscious of all the things she could think off. She started feeling trapped as she had to behave herself everyday. She was not able to live like she used to, careless and carefree. Gaurav was on her head telling her some cleanliness tip or the other.

They both were sitting and watching a romantic movie at night. Karishma was in a romantic, sensational mood after that.

'What do you think we should do now' she asked him seducingly.

He looked at her and said, 'Before everything we should change our bedsheets and vacuum this sofa. There is so much dust in here'. Krisha first stared at the sofa and then him and then again at sofa.

She couldn't see any dust on it. It was so clean according to her that there was no need to clean it for a month.

All her mood got spoiled because of the 'cleanliness drive'. She looked at the time. It was 2 o' clock at night and cleaning the house at this time was not her cup of coffee. But she actually had no option.

Gaurav took out vacuum cleaner and they both cleaned the sofa and the carpet.

'Now it looks fresh' Gaurav sounded happy.

'Yes, we should do it more often' Krisha sarcastically said.

'Yes, yes, I think we should do alternate days', Gaurav replied in a serious tone ignoring her sarcasm or not understanding the sarcasm only.

'He is crazy' Karishma murmured to herself.

It was now time to change the bed sheets. Karishma took the easier job of changing the pillow covers while Gaurav was busy spreading the bedsheet.

'Finally done'. Krisha got so relaxed and jumped on the bed. The time was 3 o' clock.

Now she was so tired that the moment she lied in the bed she fell asleep.

'Did you brush before sleeping' Gaurav whispered in her ears and she woke up suddenly. She got very pissed off.

She did not pay much attention and slept.

The next morning she woke up and she saw Gaurav was already awake.

'Good morning sweetheart' Gaurav greeted her with a kiss.

'Good morning baby' she was surprised to see him awake so early.

'So, what's cooking Mr Gaurav. You never wake up so early.' Keisha eagerly asked him.

'Yes, today i want to clean the 'rat hole'' Gaurav told her.

'What rat hole?' Karishma was displeased when she heard the word 'CLEAN'.

'Please don't mind but your bag looks like a rat hole. its so messed up. How can you find your clothes inside it. See I saw it yesterday and couldn't sleep at night. So, Lets just quickly get over it. There are so many nice wardrobes here choose one and we will arrange your clothes' Gaurav tried

to explain her that how much problem he was having from that bag.

Annoyed Krisha was staring at him wondering 'what his problem is in life'.

'See I will do it in the evening when I will come back. I will get tired right now.' Krisha tried to say it in politest manner she could.

'Don't take any tension. I am here to help, lets quickly do it' Gaurav tried to convince her and he was successful also.

She was thinking in her mind that this is completely opposite to what she thinks a live in is. She could remember Ashima telling her that marriage means a lot of adjustment from both the sides. She could feel that.

It took them half n hour to put all the stuff in its place.

'Thank you' Gaurav was happy she did this for his happiness.

Two weeks had passed and now Krisha started to get more and more furious on Gaurav. It was pretty much visible also on her face sometimes.

One Sunday, she was sitting on the sofa thinking about these two weeks which have passed. She was afraid to think that her whole life can be like this if she marries this guy. But she is the owner of her own life, she can make it or spoil it. It's in her hands.

'What is my Mam thinking about? I hope about me only' Gaurav came and sat on the sofa.

'Yes of course I am thinking about you only Gaurav' she smiled and replied back.

'What happened? You look very low'. Gaurav could feel there is some problem with her.

'See Gaurav although we are not yet in a bond of marriage but we are living together. You should understand that we both need to adjust, make each other comfortable. we cannot impose things on each other. There a lot of things which make me uncomfortable but I ignore it, you have to do the same. Every time it cannot be always about you.'

'Wait a minute Karishma, say clearly what you have to say' Gaurav interrupted her in between.

'Ok. See I am not used to all this cleanliness drive everyday. You go too far in that. The other day you opened my wardrobe and placed your finger to show me how dusty it was. I mean have you ever seen a boy friend doing this thing. There is a better way of saying right? Cant you just say to me that even wardrobes get dusty clean them whenever you get time.

See I am not used to all this. I am a pampered child of my house. But for you I am doing it without complains. I am trying to hang towels straight and tidy whenever I use it. But still there are days when I don't want to do anything. Can't you just live with it??' Karishma just kept on talking continuously.

'Hmm' Gaurav did not say even a single word.

'There is nothing to feel bad about Gaurav. If I will not tell you, whom should I tell? I feel trapped. I cannot breathe in the air of freedom since these two weeks. I cannot be me because I have to be what you want' Karishma tried to explain in different different ways.

'I understand Karishma, but I am doing all this things so that you can adjust in my house. Otherwise you will face lot of problems. I am doing it for you only' Gaurav explained his situation to her.

'I understand but don't try to teach everything at one go. Slow down a bit. Let me live and enjoy with you.' Karishma said to her in a very polite tone.

'I will try to take care of it' Gaurav said in a apologising tone.

One week passed and Gaurav tried to control himself in every possible way, but still something or the other was happening that Karishma used to get furious on.

"I hate housework,

you make beds,

you wash the dishes,

and one month later you have to start all over again."

Karishma read this joke in newspaper and she could relate to herself so much with it. It made sense for her. But that was just a joke. Her real life was in turmoils as everyday they were fighting on something or the other thing.

Karishma was thinking that what does everybody in the world wants - to be loved, to be respected. That's all she wants. she wants him to just ignore her flaws as she is doing the same.

One day Karishma Came back from work, she switched on the tap for bathing and went to her wardrobe. She wanted to wear her favourite night dress. She couldn't find it. She clearly remembered she had put it in this wardrobe while arranging things. Gaurav was not there in flat, so she picked up another one and went to take bath.

That night they were watching tv and relaxing on the couch when Gaurav told Krisha that he threw away few of her dresses and night suits because they were too old.

'What??' Krisha was dumbstruck

'See I can explain', Gaurav tried to speak but Karishma was very angry and didn't let him do it.

'You know a girls wardrobe is a extremely private affair, even my mother is not allowed to touch it. What were you doing in it? You know you threw away my favourite things. You could have asked me, I would never haver worn them. But you threw them? How can you do this? Thats enough.' Krisha sounded very upset.

That was the time they both had a very bad fight. For a few days, Krisha was not talking to him. She was leaving early for training and coming back late.

After couple of days since they fought, Krisha realised she overreacted. She shouldn't have shouted at him.

She left her office early to meet him and apologise. She bought flowers also from a shop and went straight upto her flat. She opened the door and Gaurav was not in the living room but his mobile was kept there only. She was about to go toward the kitchen to have water when she saw a Furla handbag kept on the table. She was shocked as that didn't belong to her.

She went into her room and saw Gaurav and a girl in the bed making out. She couldn't believe her eyes. She took her clothes and bag and left the place.

Gaurav ran behind her shouting that its not what you think it is. Everything was futile. Keisha had enough break ups in her life where overtime the guy cheated her and this time she was madly in love with him and now what she saw was unbelievable. She tried to be strong. She knew this time she will not bend. She has suffered a lot and now she will not feel weak in front of her love no matter what his explanation is.

She broke up with him. Gaurav messaged her telling her that she was a random girl he met and it just happened

because he was upset. He further told her that he loves her and will wait for her forever.

Krisha was too strong this time and she decided that self respect is what she wants more than a boy.

Chapter 22

When life is sweet, say thank you and celebrate. When life is bitter, say thank you and grow.

Sometimes life could get so bitter that you'll only be only left with two options: either continue leading the same life or take a stand to change it. Karishma was in the same state where she had to choose between her freedom or bondage. She thought to completely forget about Gaurav, that will be best for her. But her entire life was dependent on this decision. She closed her eyes and started to think about what really happened between them. Although it was not a very huge thing that happened with her, but the thing is about her self respect.

Karishma didn't want to lead a life where she is not accepted the way she is, but she has to change herself to be with the guy. Her decision of moving out of such life was not an easy decision.

She could recapitulate the moment she stepped out of the house, she felt fresh breeze blowing over her face as if it

When life is sweet, say thank you and celebrate.
When life is bitter, say thank you and grow.

was welcoming her into a new life. She realised all the downs and the sufferings she has faced in her life have made her strong and capable enough in taking that big step of her life. She had finally figured out her worth, and for that *self-worth*, she has raised her head in front of her boyfriend and boarded a flight to freedom that landed her in the castle of change, the change for good.

Some women are not meant to be tamed, and Karishma proved that she was surely not one of them.

She completed her training and came back to her house in t Miyawali Nagar. Her parents were happy to see their daughter after three months., but before they could say or ask anything, Krisha started speaking, 'Throughout these years, I believed a man who could get you stunning shiny pieces of stones can keep you happy throughout your life. But after living my dreamy life, I have realised that those shiny stones are nothing in comparison to love and respect. Things can come and go, but what makes your life worth living is much beyond. I have now understood how wrong I was, but as it is said, "It's never too late".' And she hugged her parents after completing her line.

Karishma sounded happy; she sounded satisfied and confident. The aura that she used to have on her glowing face and got lost in her tears could be seen coming back on her face. She was feeling like a free bird now that has been freed from her cage and was now ready to fly high in the sky. She went to her room and decided to drop a text message to Siddhant and Aashima.

'Guys, thank you for making me realise what I was losing in life. I always thought money is all you need to live your life, but you made me realise how wrong I was. I was lonely that my life demanded "friends" who take care of me

like my "family". I know I have behaved very badly with you guys in the past. I can't make up for those mistakes, but I promise you that I'll improve myself. I have broken all chains that were tied to me, and now I want to soar high in the sky. I want to live my life according to me, on my own terms and conditions. You are the people who gave who matter the most in my life. Thank you and love you guys. Karishma (the changed one)'

Finally Karishma was free from all the illogical restrictions and boundaries she was following forcefully while she was tied in the chains of sorrows and grief with a man who gave her pain, tears, not love and care. She was happy now, living with her parents and their endless love, with her caring friends around who have supported her throughout her life and always stood by her in the ups and downs of her life. She was finally herself, the happy bubbly Karishma, but with boldness in her attitude and clarity in her thoughts. But still somewhere down her heart she missed being with Gaurav. She missed time spent with him. Because he used to care for her a lot.

Meanwhile, Gaurav also missed Karishma. He knew he was too authoritative and he realised that it's on him that a girl can adjust in his house. She doesn't have to change. What matters in the end is how much she loves and cares for him which was over and above everything.

Aashima decided to plan out a lunch and asked both, Karishma and Siddhant to meet her at her parents' house, and soon they were there. They saw each other and gave a group hug like they used to give to each other before. They were re-united this time wholeheartedly. The hardships of life made them grow strong and know the worth of each

other. They started chatting and continued discussing their childhood memories for hours. They were laughing and shouting out of joy. They were enjoying their company. Both, Siddhant and Aashima were happy to see their friend has forgotten all her pains and moving on with a smile on her face.

'I've good news for you both,' Siddhant excitedly said.

'I've been offered one song which I have to sing and compose for an upcoming Punjabi movie,' Siddhant said with a big smile on his face.

'Congratulations,! This is so awesome,' Aashima said and hugged Siddhant.

Both Karishma and Aashima were very happy after hearing that news. Yes, indeed it was good news, Siddhant's hard work and struggles were finally paying off, and his best friends were very proud of him.

'Krisha, when are going to join your job?' Siddhant asked Karishma.

Karishma had taken a break from her monotonous job for a while.

'I don't know, I don't want to get back into the same job or the same working environment that is related to my past. I'll start looking for a job soon. I hope to find a good and suitable one soon, let's see,' Karishma replied after giving a thought over his question.

'I am are looking for a managing head who'll be managing my dealings and everything with the people for our label from past couple of days. So if you like the job, do you want to join me?' Siddhant asked Karishma.

'Are you serious?' Krisha looked at him doubtfully.

'Yes! Of course, Karishma, you are the perfect person for this post. I wanted to ask you this job earlier also, but

then things were different, and I couldn't. That post is still vacant, and you are what I want in my company,' Siddhant explained.

After thinking for couple of seconds, Karishma said *yes* with a big smile on her face. She was looking very happy and excited. She thanked Siddhant and hugged him tightly. Her eyes got little moist out of happiness.

There was no looking back after that day in Karishma's life. She soon joined Siddhant's music company and started giving her 100 per cent in taking it to the new heights.

* * *

'Oh! Hello? Where are you lost?' Krisha shouted at me and brought me back from my memories.

'Nowhere, Krisha, just random thoughts,' I replied.

'Hurry Up! We are getting late,' Karishma said and pointed to her watch.

I realised that I was lost in my memories from quite so long and didn't have any idea about the time.

'Where is Udyan?'

'He is with his owners,' I heard Aashima's voice from behind and saw her standing there with Palash and little Udyan in his arms.

'Sid, please you hurry up, you have to be on stage in the next half an hour, and these organisers are calling me again and again. Punit was also asking for you. Go and get ready,' Karishma said and started pushing me.

'I have a surprise for you Karishma' Sid told Karishma.

'Emma is coming?' Karishma asked curiously.

'No, just look behind you'. Karishma turned and she saw Gaurav standing there.

When life is sweet, say thank you and celebrate.
When life is bitter, say thank you and grow.

Karishma started to cry when she saw him. He came towards her, dropped on his knees and said "I was wrong, I wanted to change you. I have realised my mistake— forgive me please."

Karishma gave him a tight hug and started hitting him.

'What took you so long to come?' and they both hugged each other when Karishma realised Sid has to go live. He was getting late.

The crowd was chanting my name even when I've stopped singing. They loved me, and they adored my work, to which I am indebted. I respect them all, and I'll keep reciprocating their love by entertaining them throughout my life. But the people who I adore and will keep on adoring throughout my life are standing right in front of the stage, cheering and shouting for me. Aashima, my best friend who never required words to understand my feelings; Emma, the love of my life and with whom I'll raise a family one day; Palash, and Ayushman, with whom I can abuse and get passed out on drunken nights; little Udyan who is my little sweetheart; and Karishma, the strongest girl I've seen. Today, when I am looking at her, only one thing comes in my mind that *you have to stand up for yourself because nobody else will.* Being silent about how you feel or what you feel is emotional suicide, which she refused to do. New beginnings are often disguised as painful endings, but that's how life is.

Karishma stood for herself and in the end Gaurav had to bend down for her. That's what's required today. Girls need to stand up for themselves. If they will, problems will definitely come on their knees, saying sorry.

Do Try!! Wise advice and remember: You are the master of your life, and you can take it wherever you want to.